ERNST RÖTTGER AND DIETER KLANTE

# CREATIVE DRAWING
## Point and Line

**VNR** VAN NOSTRAND REINHOLD COMPANY
New York Cincinnati Toronto London Melbourne

Van Nostrand Reinhold Company Regional Offices:
New York   Cincinnati   Chicago   Millbrae   Dallas

Van Nostrand Reinhold Company International Offices:
London                Toronto                Melbourne

Copyright © 1963 by Otto Maier Verlag, Ravensburg, Germany
Library of Congress Catalog Card Number: 64-13649

ISBN: 0-442-27082-8 paper
ISBN: 0-442-11042-1 cloth

Published by Van Nostrand Reinhold Company
A Division of Litton Educational Publishing, Inc.
450 West 33rd Street, New York, N.Y. 10001

10  11  12  13  14  15  16

This foreword cannot overlook those written for the previous volumes in the Creative Play Series. To them should now be added a retrospective warning. Although it may have been already well understood, there is still some danger to the whole series of being misconstrued, not to say misused, as a mere collection of recipes which if conscientiously followed will automatically result in perfect art teaching.

As long as the quickening stream of inspired teaching and inspiring practice continues to flow from the spring of originality the process is natural and beneficial. However, when the bubbling water is put into bottles (in this case into books) it may well be delivered all over the world, but the many consumers are then exposed to the constant temptation of merely copying the techniques illustrated instead of understanding the spirit behind them. It should be clear that there is no rigid scheme in this subject and that these forms of creative play contain, regardless of the rules of the game, an inexhaustible number of variants of which only a relatively small proportion can be demonstrated in this and the other volumes. This series of books is in no way meant to incite mere dull imitation but should rather act as a starting point for further original development. To use it in this way is the sign of a truly creative art teacher.

There is another reason why this book should not be seen in isolation. Although limited to point and line it has a connection with the preceding volumes, in particular with the first, in which paper, as the flattest of flat planes, serves to demonstrate the importance of mastering pure line before taking up pencil and brush. The following pages are devoted to creative play with line, either controlled or in free exercise. It should also be free in the sense that the hand and forearm should avoid using the table as a firm rest, drawing instead being executed directly onto the board. Furthermore the badly neglected left hand should come into its own, after the example of Adolf Menzel, who was able to draw with both hands.

The creative use of line rightly includes script and punctuation. Practice with the Chinese brush and even a goose quill is a valuable antidote to the general standardisation of handwriting caused by the ball-point pen. Even lines drawn with the aid of T-square, compass and ruler have their place in the creative ordering of form and in free play, once they are understood as an aid to 'writing in' the outlines of figurative and spatial forms.

Play with line leads logically to a fresh way of looking at nature. Today this is often thought outmoded, because some blinkered minds will not realise that it does not need a great effort of imagination to break nature's spell. Observation and imagination thus merge inextricably, as when children (whether from imagination or memory is immaterial) try to draw objects, flowers, animals or their own reflections in the mirror.

It cannot be said too often that the material in these pages should not be slavishly copied. It consists mainly of suggestions for releasing, developing and maintaining the creative energy of young people within the elastic discipline of play, in which the use of line is most appropriate as both symbol and practice.

Stephan Hirzel

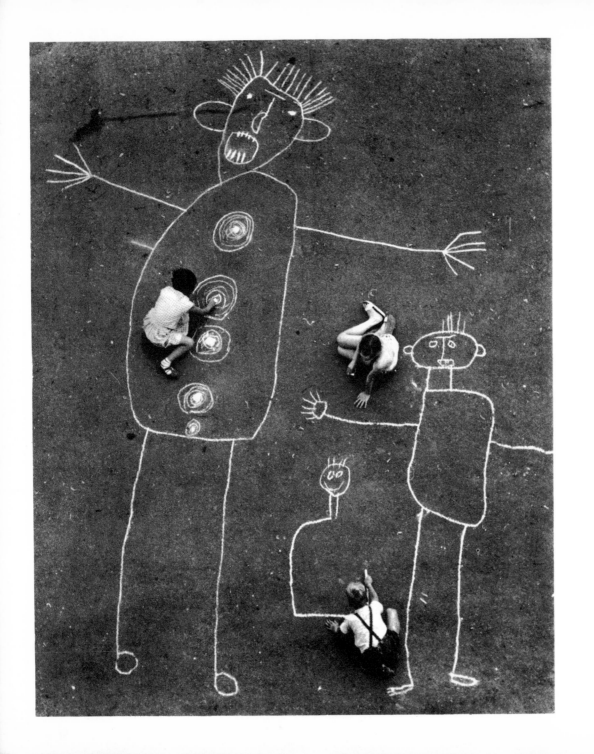

**Foreword**                                                        **3**

**Introduction**

Creative picture making                                             **6**
Children's drawings                                                 **8**

**Examples of creative play**

Point as a pictorial element                                       **30**
Line as a pictorial element                                        **35**
Rhythmic articulation of planes by simple, wavy,
hatched and interwoven line, configuration and
figurative representation                                          **46**
Script as rhythmic line                                            **76**
Blown lines                                                        **78**
Point and line in shades of grey                                   **80**
Two-handed line drawing                                            **82**
Cut-out line                                                       **85**
Stamped line                                                       **86**
Encised line                                                       **88**
Scratched line                                                     **90**
Monotype                                                           **92**
Texture in point and line                                          **94**
Line drawn with ruler and compass                                  **97**
Figurative drawing from the imagination                           **100**
Line in parallel projection                                       **108**
Studies in texture                                                **111**
Studies from nature                                                **116**
Plastic line: Glued thread: Stretched thread                      **132**
Use of line in various materials                                   **143**

Besides those materials whose characteristics suggest and determine the nature of plastic art, it is above all the elements of pictorial creation which, because of their great expressive potential and their limitless variety, provoke a challenge to creative play. In pictorial structure we distinguish between the skeletal graphic element, the expressiveness of colour and spatial and plastic form.

The basic components of graphic expression are point and line. The starting point for all the examples suggested in this book is the plane. The aim of the process is the rhythmic articulation of a plane or an ordered composition inscribed on a plane (configuration of point and line).

A systematically arranged sequence of exercises was used in previous volumes of this series, which by controlled limitation of material both encourage a sense of discovery and teach discipline in the handling of tools. A similar sequence of exercises is also used in this book. It should be pointed out that the examples of studies from nature and of figurative representation are primarily meant to be judged by the way the materials are used and by their purely pictorial quality rather then as reproductions of optical phenomena. In many of the examples the thoughtful observer will recognise the affinity between the forms produced in creative play and organic forms in nature. Often the creation of form on the drawing paper reflects the genesis and growth of natural forms. Thus a flowing line will alter its course when faced by an obstacle, the vertical line rising from the horizontal branches out, wavy lines are repeated in the structure of water, air or hair. Points that are closely or widely separated resemble the texture of sand or the stars of the Milky Way.

Creative picture making teaches those who practise it to observe natural forms in their beauty and inexhaustible variety much more carefully then before.

There is nothing new about it. The urge towards pictorial expression exists in everybody, child or adult. The small child starts drawing spontaneously. Even dignified old gentlemen pick up a pencil at boring conferences and put strange figures on paper. Their drawings show, of course, that their graphic skill has remained at the level of infantile scribbling. Neither in the home, nor at school has this fundamental human urge been properly developed.

Once one learned 'drawing'. This meant the realistic copying of a model. It was the new methods of the art education movement which first showed the way to give a proper outlet to the urge towards pictorial play.

This book sets out to show the correct way to develop graphic fluency and also to preserve it throughout the critical age of puberty and beyond. The examples collated in this book are chiefly the results of controlled play with the basic pictorial elements of point and line. As every game must have rules to prevent its degenerating into triviality, equally so must creative picture making be guided by rules. True play is not over-concerned with the result; it is self-justifying. Learning to make pictures in this way becomes a satisfying and constructive activity.

<div align="right">Ernst Röttger</div>

**Symbols used:**

**S** = Work by students of the State High School of Applied Arts, Kassel

**A** = Work by amateurs, mostly from adult education classes

**B** = Work by boys

**G** = Work by girls

The subsequent figures indicate the age of the executant.

Examples illustrated in this book originate, with the exceptions listed below, from classes given by Ernst Röttger and Dieter Klante.

From classes given by:

M Kristl: Figures 47, 87, 88; Hans Dobe: Figures 167, 168, 225, 224, 225, 341, 344, 461, 463; Heinz Hüttel: Figure 223; Herbert Krause: Figures 338, 339; Rudolf Kroth: 256, 257; Hans Leistikow: Figure 258; Kay H. Nebel: Figures 392, 416, 417; Walter Schmidt: Figures 340, 342, 343; Hans-Jürgen Spohn: Figures 122-126, 195-198, 253.

# CHILDREN'S DRAWINGS

The pictorial language of children has been a constant subject of scientific research, chiefly from the angles of psychology and anthropology. There is an extensive literature about it. Here, however, this viewpoint must give place to another. The intention is primarily to study the pictorial quality of children's drawing. It should be stated at the outset that children's drawing has quality, and the next few pages are to be seen less as proof than as appreciation thereof.

The observer is constantly fascinated by the sureness with which the infant, above all, employs line as a means of graphic expression. In its clarity childish drawing cannot but be an example to the adult who is no longer in the fortunate position of the child in being able to create from the security of a naive conceptual world. For this reason children's drawing has been placed at the head of the main chapters of this book.

The process is easily followed. A small child plays with a pencil. His arm moves over the paper in large movements to and fro, up and down, in circles, and he watches the emerging results with satisfaction; the effect

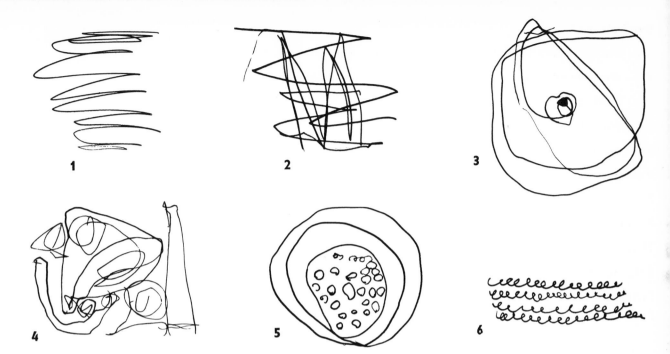

**1-4: Infant scribbles.**   **5: First representational drawing: Nest of Eggs.**   **6: Simulated writing.**

induces pleasure. For a start this is enough, and so are produced the typical, apparently disorderly jumbles of lines of the scribbling stage, but which - surprisingly - often already exhibit a rhythmic articulation. Later the child starts to make his drawings explicit. The meaning is not yet fixed and the same doodle can serve as required for mummy, daddy, dog, house or car. But soon the drawings begin to show the first characteristics of creatures and things from the child's environment. The first signs for man, animal, plant and house appear and soon the child's pictorial language is revealed in its full richness.

Here is illustrated a selection of children's work, from the first infant scribbles to the drawings of twelve-year-olds. Not all represent spontaneous expression; in some the guiding hand of the teacher is detectable, of which more will be said in the appropriate section of the book. It should be stressed that this is not a selection of work by those specially talented, but rather by 'normal' children whose pictorial language has remained sound.

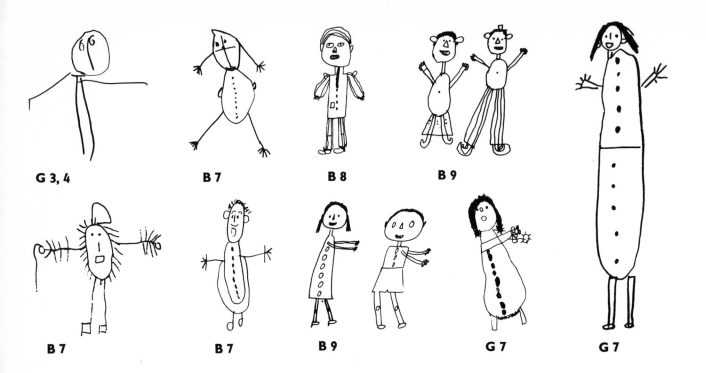

G 3, 4     B 7     B 8     B 9

B 7     B 7     B 9     G 7     G 7

Children's drawings of people, trees, animals, houses. The differences are not only due to the varying ages and stages of development, but also indicate fundamental differences of conception. The richness of form illustrates the vitality of children's pictorial language. It is in no way reducible - as people often erroneously think - to a few clumsy archetypes.

Drawings by infant school pupils.

36-38, 41: 'Little John...' ('Hänschen klein', German nursery rhyme). The impulse to draw came from singing the song in class; no other help was given.

36: At first sight a primitive-looking drawing, yet everything needed to illustrate the little story is there: Johnny, sun, hills, meadow, path, woods, flowers are laid on the plane, well spaced, like symbolic archetypes.

38: Drawing by the same boy six months later. An amazing increase in differentiation.

39: 'I wish I lived in the forest...'

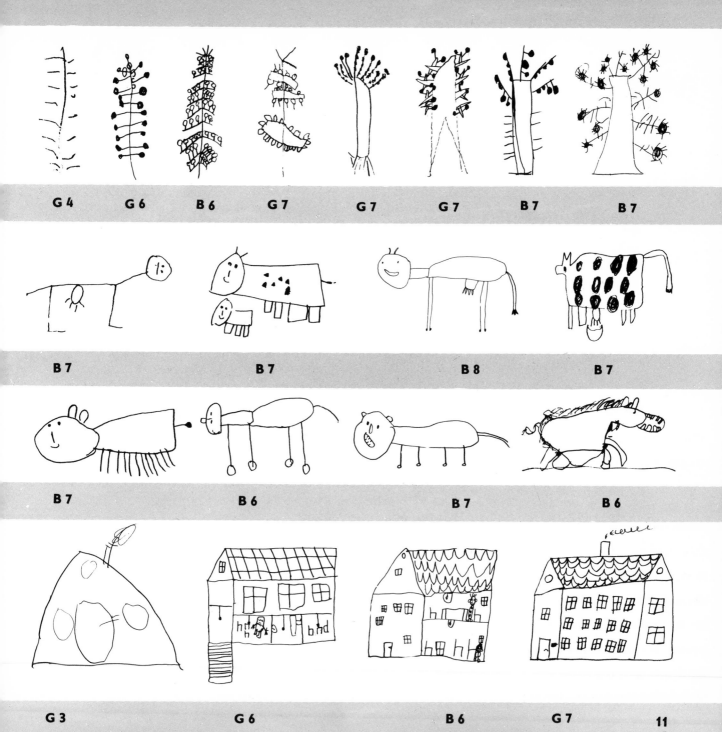

G 4　　　G 6　　　B 6　　　G 7　　　G 7　　　G 7　　　B 7　　　B 7

B 7　　　　　　B 7　　　　　　B 8　　　　　　B 7

B 7　　　　　　B 6　　　　　　B 7　　　　　　B 6

G 3　　　　　　G 6　　　　　　B 6　　　　　　G 7　　**11**

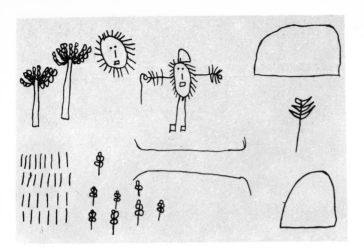

**36 B 7**

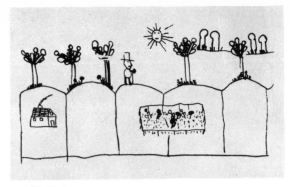

**37 B 6**

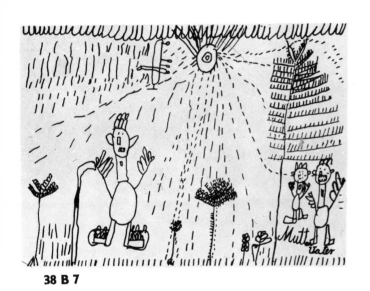

**38 B 7**

**39 B 7**

## 40-42: Blackboard drawings

Children want to draw big, preferably using the whole body. The intensity with which the child seeks to experience spatial relationships is shown in the way that he will, while more or less on the run, scratch a gigantic figure on the ground with a stick or draw one on a huge scale with chalk on the asphalt. We should take account of this urge and at least give the child plenty of opportunities to draw on a blackboard.

12

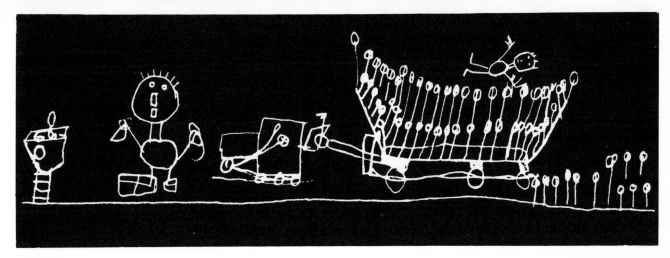

40 B 7

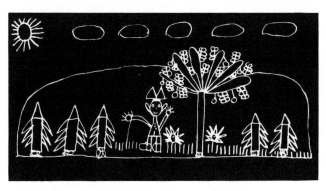

41 B 6

42 B 6

40: 'Harvest home.'

42: 'Farmer with cow.' Man and beast are identified as living creatures. What is for the child the decisive difference - the upright attitude of the man and the horizontal attitude of the animal - is emphasised by the strongly pointed vertical-horizontal contrast.

43: 'Dodgems.' The strength of expression lies in the concentration on essentials.

44: The first conflict of viewpoint. The boiler of the locomotive is still drawn in X-ray fashion whilst the stoker is shown as partly masked by the cab.

43 B 7

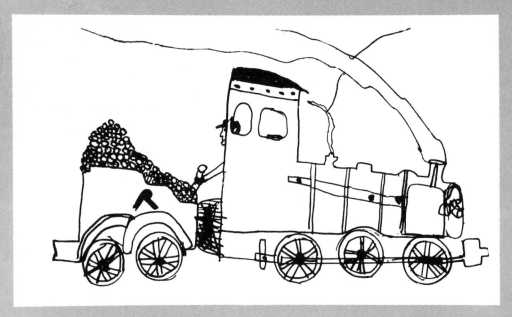

44 B 8

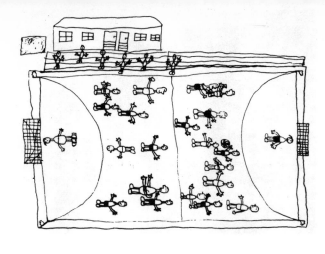

45 B 8

46 B 9

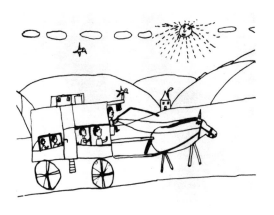

47 B 8

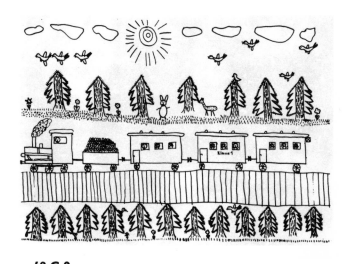

48 G 9

45: 'Football game.' The boy draws from a bird's eye view, starting with the exact layout of the school games pitch. Players and spectators were then set down within the plan.

46: 'The electric fence.' Drawn after an episode during the school outing.

47, 48: 'Stagecoach' and 'Railway journey'; both in side view. In 48 note the strong emphasis on dividing up into blocks and rows. Children draw things in their characteristic aspect, i.e. from the side which typifies them. Thus the railway lines are shown in plan.

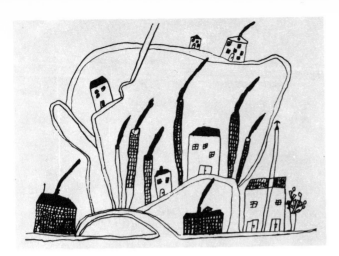

**49 B 8**

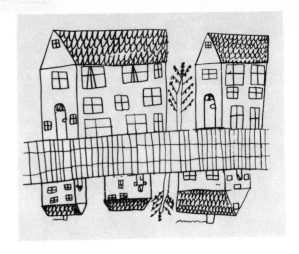

**50 B 10**

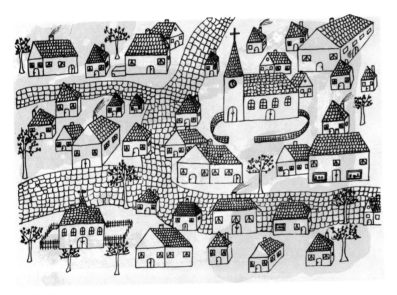

**51 B 11**

**52 B 9**

Various solutions of the exercise: 'Our village, our church, our town.'

49, 53: First the street network is drawn as in a ground plan, then the houses are added. Overlapping is avoided.

50: A type of representation generally called 'topsy turvy', but which is not so at all. The houses on both sides of the street are in a completely consistent relationship to the street.

16

**53 B 11**

**54 B 12**

**55 B 9**

**56 B 11**

51: Although this is a mixture of flat and spatial representation, it achieves pictorial unity.

54: 'Industrial town.' Side elevation with overlapping.

56: 'Skyscraper city.'

57 B 11       58 B 10       59 B 12

When choosing subjecs the teacher should bear in mind the way in which children's interests change with the time of year. The various seasons, particularly the festivals, and the subject-matter of other branches of teaching all offer plenty of material. Hence these pictures of Christmas trees and the three shepherds. The story of Goliath in pictures and the scene of the Last Supper were suggested by Bible study.

Examples of subjects from the child's own experience: 'The ice-creamseller', 'People going to the station'.

65, 66: The egocentric conception of the eight-year-old.

67: A lively and particularly attractive drawing by a twelve-year-old.

68: Clear grouping without overlapping.

69: Conscious and skilfully handled use of overlapping; movement makes it strongly expressive.

60 B 11

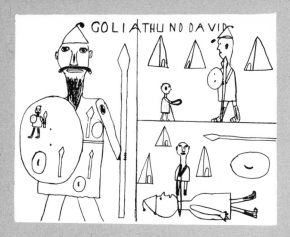

61 B 10

62 B 9

63 B 11

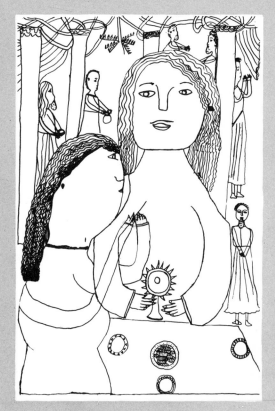

64 G 12

65 B 8

66 B 8

67 B 12

68 B 10

69 B 11

70 B 12

71 B 11

72 G 12

73 B 11

74 B 14

Drawings made under the direction of the teacher with strictly limited themes and so organised that the theme could only be expressed graphically in point, line and texture.

**75 B 12**

**76 B 12**

**77 B 12**

**78 B 12**

**79 B 11**

Thus the theme 'Park' for example in 70 and 72 is restricted to trees, grass and paths. It is particularly clear in 70 how the individually textured planes are interrelated and how surely the pupil has utilised contrast as a means of figuration.

80 B 12

81 B 12

'In the playground'. Figure 80 is specially notable for the clarity of its composition. Overlapping is avoided. Here too things are represented from their characteristic aspect, e.g. the slide and the sandpit are drawn in plan.

82 G 12

83 B 11

84 B 12

85 B 12

86 B 12

87 G 12

88 G 12

84, 86: 'Our family at lunch.' Naively but properly the boy has combined several means of representation (86). A powerfully expressive piece of graphic work.

85: 'Chanticleer'. Of course the twelve-year-old knows that the cockerel has only two legs, but he senses the four-four-four rhythm of legs (donkey, dog, cat) would be disturbed so he unconcernedly gives the cockerel two extra legs.

87, 88: 'The Princess and the Pea', 'The Sleeping Beauty.' Strongly original drawings of a girl which indicate delight in formal discipline and pronounced feeling for decoration.

Illustrations of fairy stories are universally popular subjects for drawing, yet there are serious objections to them. From picture books children get to know too many illustrations which - mostly quite un-childlike and

89 G 12

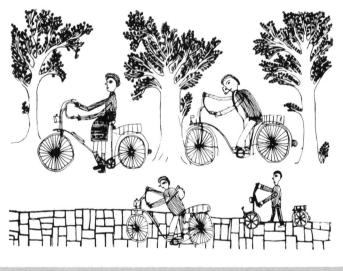

90 G 12

91 G 13

92 B 13

89-92: 'Our school outing'.

inferior in formal values - are detrimental to the free development of their own pictorial ability. This affects older children in particular, who are subject to a great deal of external influence when they are at the stage of making sense of their environment.

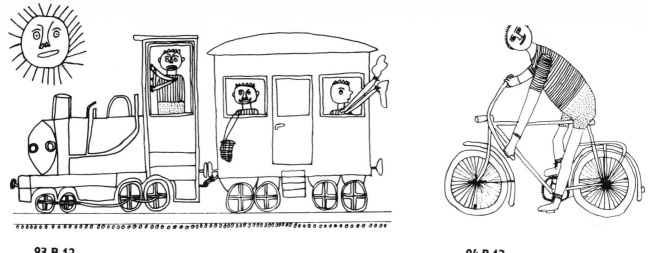

93 B 12

94 B 13

95 B 13

96 B 12

By choosing appropriate subjects we should try to counteract outside influence and keep the child's pictorial idiom sound. Care, too, should be taken not to excite the child's imagination too violently with 'fantastic' subjects. Themes from the world of the child's own experience are always successful.

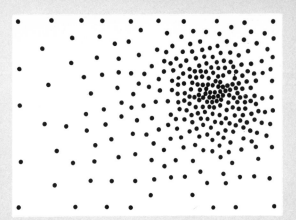

97 S

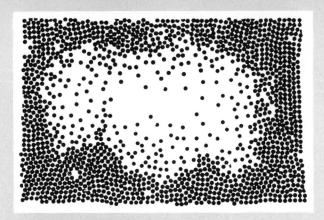

98 S

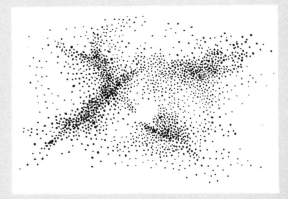

99 S

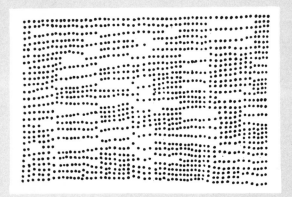

100 S

The section 'Children's Drawing' showed drawing that was original and aided only by the subject being chosen and the contents of the pictures being discussed. The following chapters show, in systematic order, results of exercises in the serious study of point and line as pictorial elements.

## POINT AS A PICTORIAL ELEMENT

Planned work presupposes discipline, i.e. in this ceas clear delineation of the exercises through rules which limit the scope of each stage in the game.

97, 98: Scattered points of equal weight; in 97 thickening towards the centre, in 98 thickening towards the edges.

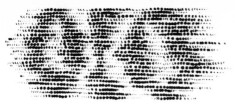

101 S

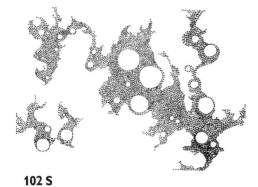

102 S

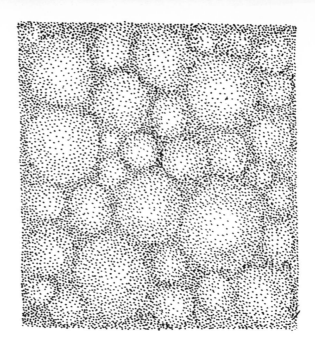

103 S

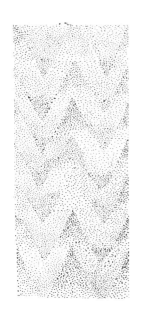

104 S

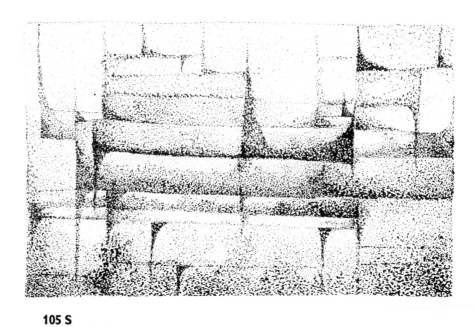

105 S

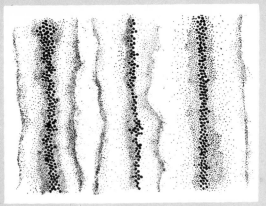

106 S

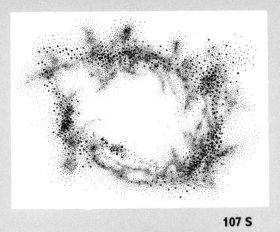

107 S

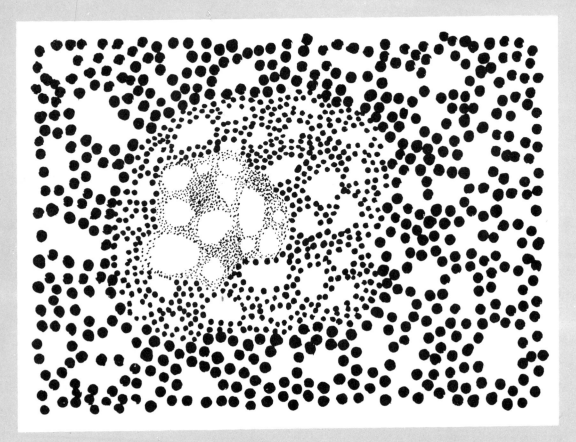

108 S

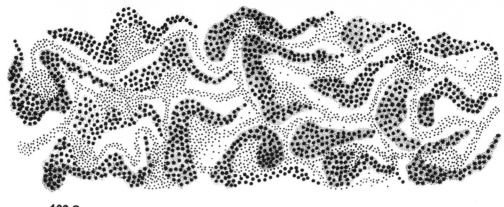

109 S

The points are stamped out of paper with a punch, enabling them to be rearranged until the 'game' results in a satisfactory solution.

100: Loose rows. The points are applied by even pressure with a felt pen.

101-110: Dispersion, rows and figuration with points of both equal and unequal size, producing images varying in effect from flat to three-dimensional.

111: Articulation of a plane with points and circles.

It is interesting to note how, quite unintentionally, point figuration gives rise to forms which are also found in nature. This is especially marked in Figures 107 and 110 whose texture is reminiscent of stellar galaxies.

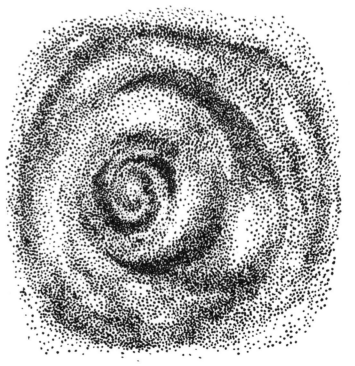

110 S

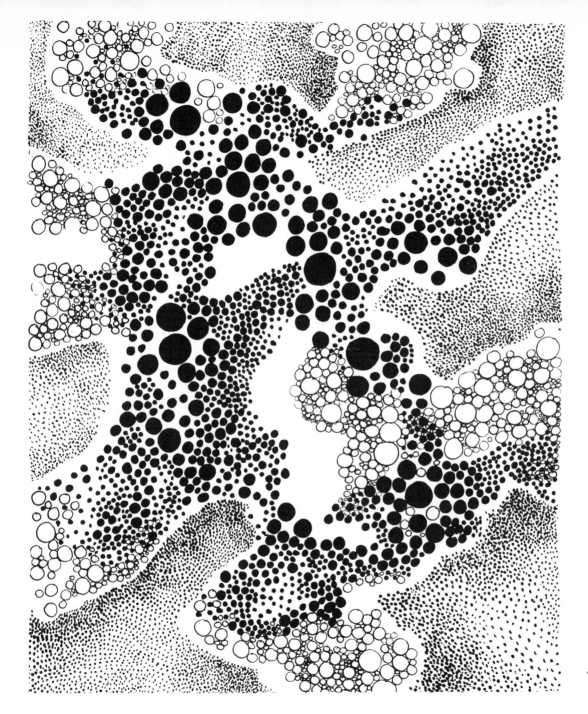

111 S

34

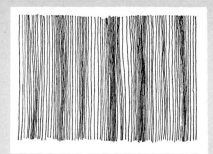

112 S

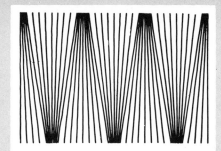

113 S

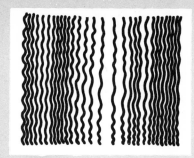

114 S

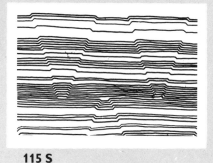

115 S

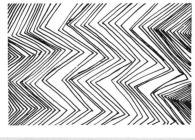

116 G 13

117 S

# LINE AS A PICTORIAL ELEMENT

The use of line begins with quite simple exercises. Figures 112 - 117 show examples from a consistent series of exercises in which the object was to articulate a surface with straight, bent, interrupted and wavy lines.

It is advisable to work out 30 to 50 variants of an exercise on paper of small format (about 6 x 8 inches) and also to use different tools (ball-points, pens of varying widths, pencils, felt pens, paint-brushes). Only by frequent practice can one gain an idea of the limitless variety of solutions to such a simple exercise and in doing so develop a sense of form. The best results are then repeated in bigger format, in most cases necessitating a thicker line and probably a different tool.

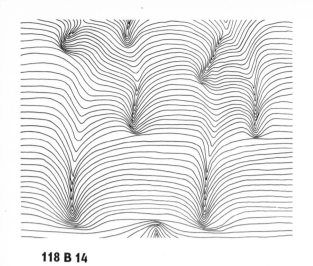

**118 B 14**

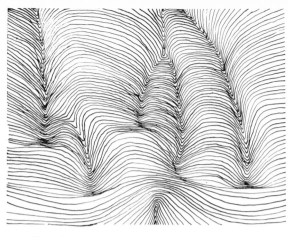

**119 G 14**

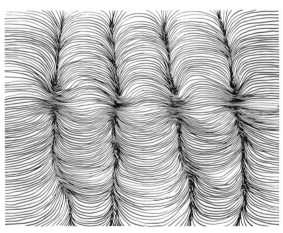

**120 G 15**

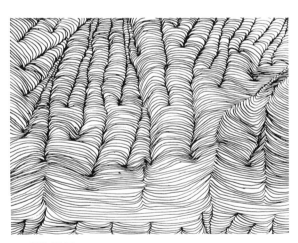

**121 G 14**

The exercise set for Figures 118 - 124 was to draw a wavy line from left to right across the middle of a plane. Parallel to this above and below it further lines were to be drawn, closer to each other at the curves so as to create areas of concentration. Alternating tension and relaxation give a plastic quality to the linear texture.

Formats of the originals: 118 - 121, about $11\frac{1}{2}$ x $16\frac{1}{2}$ inches ; 122 - 124, about 24 x 34 inches

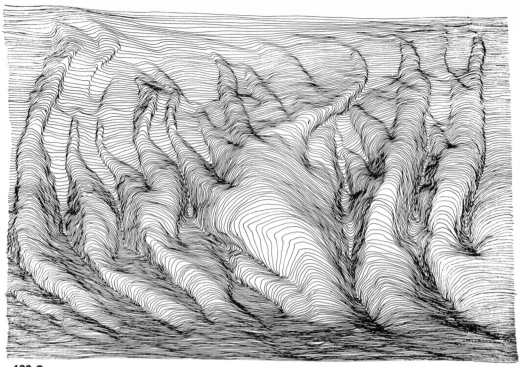

**122 S**

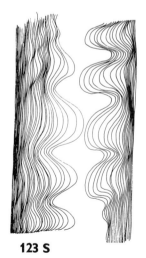

**123 S**

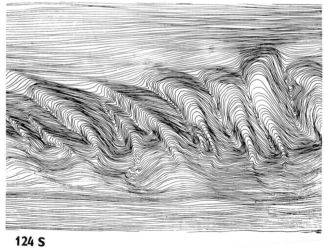

**124 S**

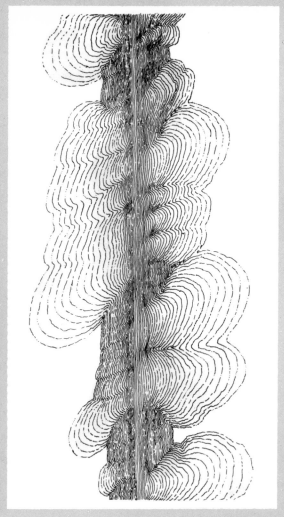

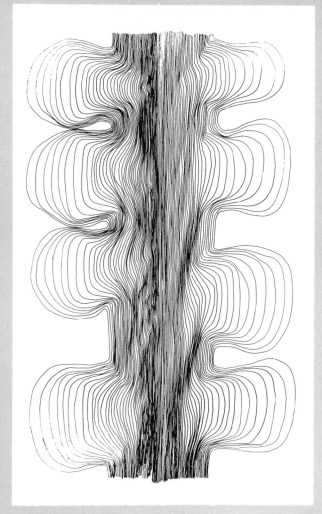

125 S

126 S

125, 126: Here a straight line was drawn vertically down the middle of the sheet with further lines added on either side which were made to bulge out to an increasing degree without touching each other.

Both these modest exercises, based entirely on pure graphic elements, teach the rules of composition which were so fundamental to the work of the great masters of the past. Pupils will thus learn to appreciate the draughtsmanship of old masters with new eyes and to evaluate it not only for its subject-matter but also from the formal aspect, i.e. for pictorial quality of line.

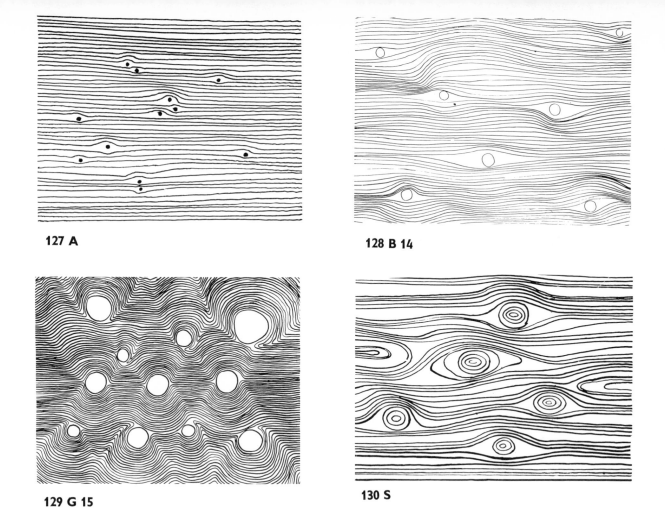

**127 A**

**128 B 14**

**129 G 15**

**130 S**

Linear flow emphasised by introduction of random motifs.

127: A certain number of points are dotted at random over the sheet. Parallel lines running from left to right are then made to flow gently round these points without touching them.

128-130: Circular forms introduced into the linear movement.

These few examples again recall the splendid patterns produced by the creative forces of nature (wood graining, flowing water).

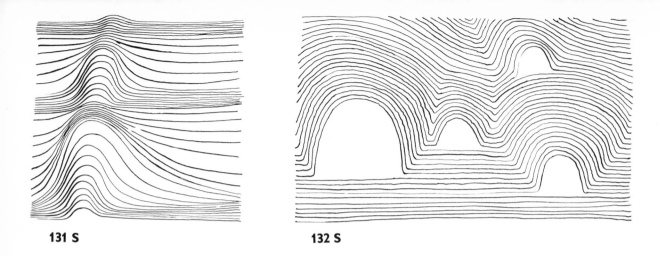

131 S

132 S

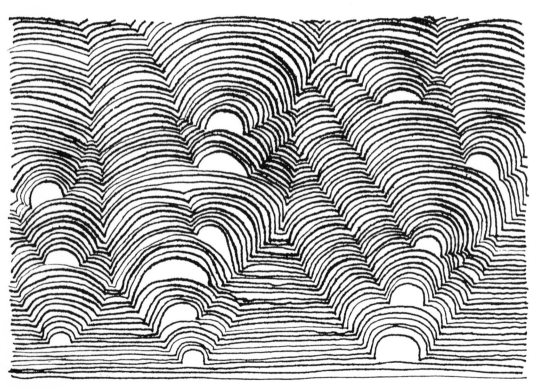

133 S

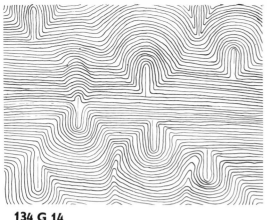

**134 G 14**

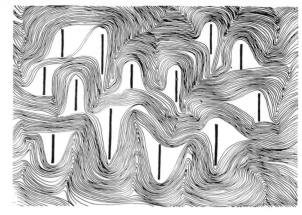

**135 S**

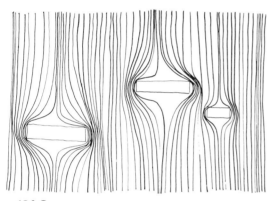

**136 S**

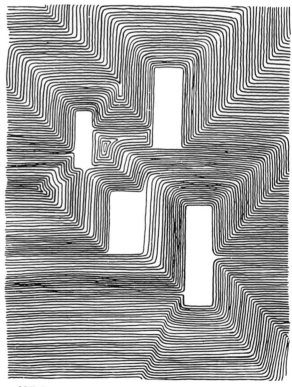

**137 S**

**132-138:**

**Examples of the introduction of spatial and solid forms.**

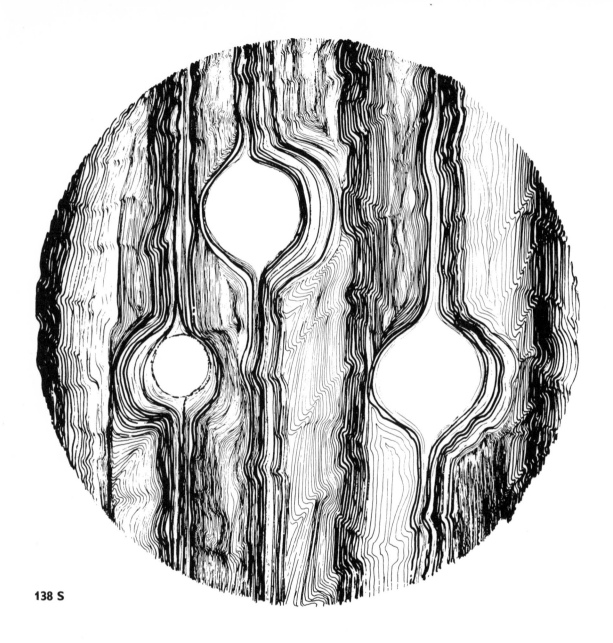

138 S

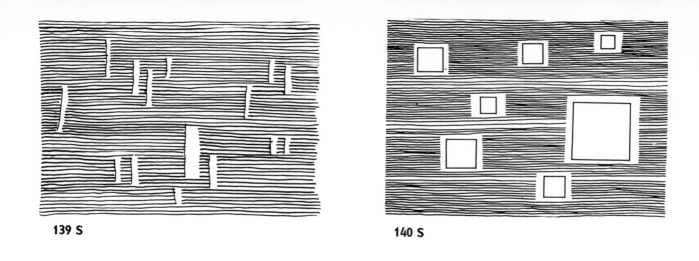

**139 S**

**140 S**

**141 S**

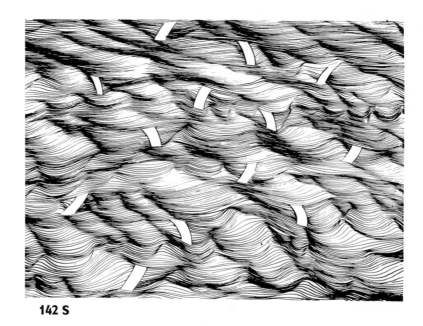

**142 S**

139-143: Interruption of line by 'obstacles'.

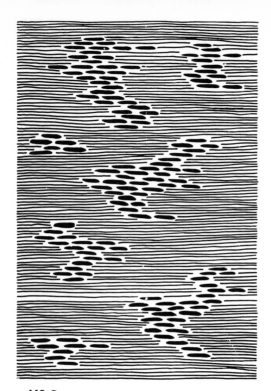

**143 S**

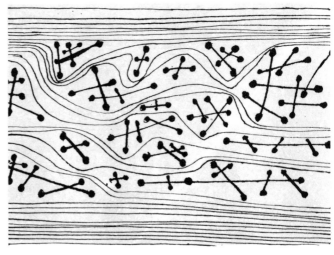

**144 S**

**145 S**

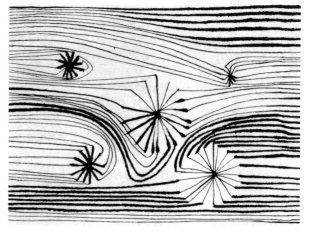

**146 S**

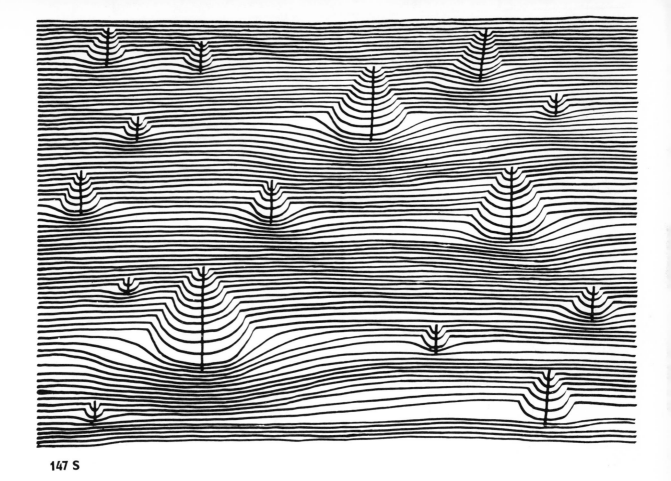

147 S

144: Increased tension created by the introduction of 'barriers'.

145, 146: Examples of how, in the free development of an exercise, linear flow is determined by forms placed at random on the sheet.

147: An exemplary solution of the problem of integrating plant forms into a linear flow.

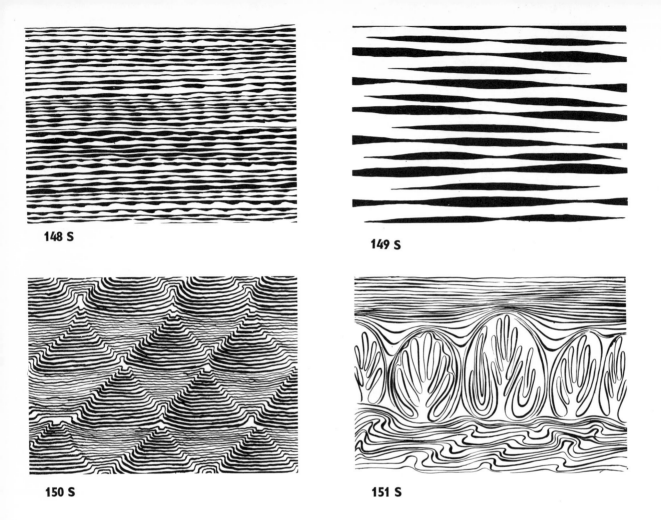

148 S

149 S

150 S

151 S

# RHYTHMIC LINE

A line takes on quite a different character when it is drawn with varying thickness. The rhythmically swelling effect is achieved with a lettering pen by turning the nib, with a brush by varying the pressure.

148, 149: Two fundamentally different solutions of a simple exercise: dividing up a plane with horizontal lines. Drawn with a brush.

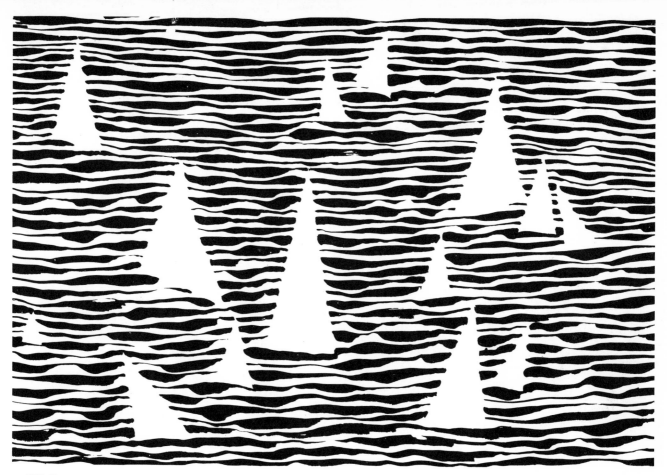

**152 S**

150: Severe treatment, creating a plastic effect.

151: Thematically linked exercise. 'Air', 'Water' and 'Earth' are symbolised in three horizontal fields.

152: Several triangles with good dispersal were drawn with a pencil on a given plane and then retained as gaps in a brushdrawn texture study suggesting water.

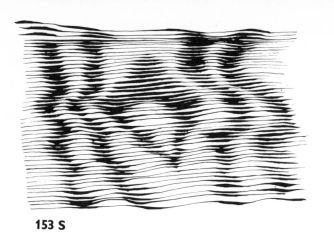

153 S

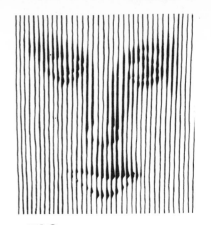

154 S

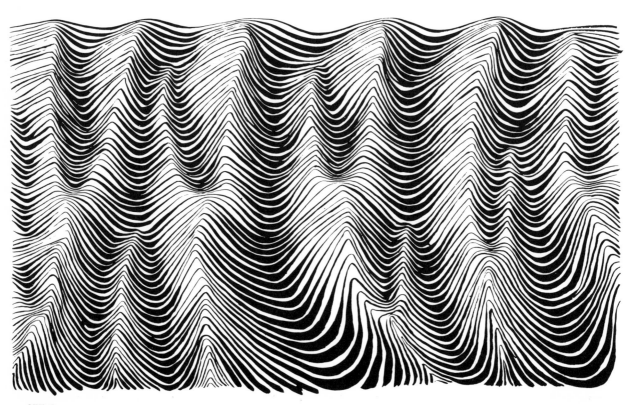

155 S

48

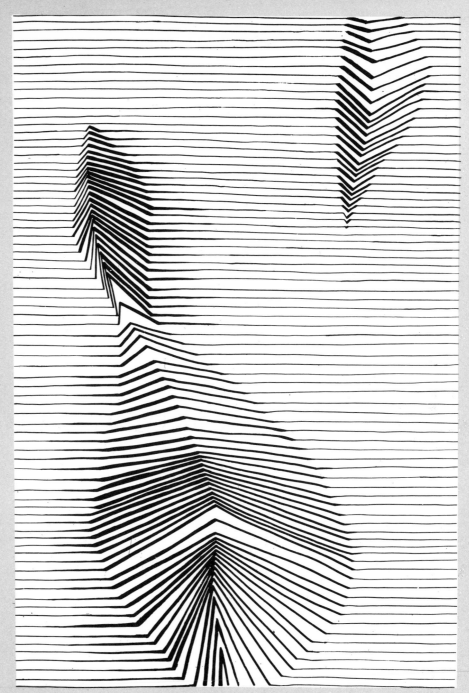

153: Unusual wavy figurations in a linear field, achieved by controlled grouping of thicker line.

155: Linear structure with markedly plastic effect.

156: A severe linear pattern into which relief is introduced by forms drawn with a broad nib.

156 S

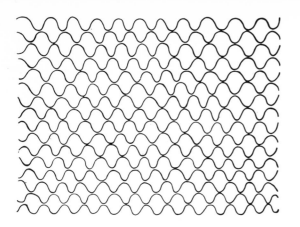

**157 S**

**158 S**

**159 S**

**160 S**

**161 S**

**162 S**

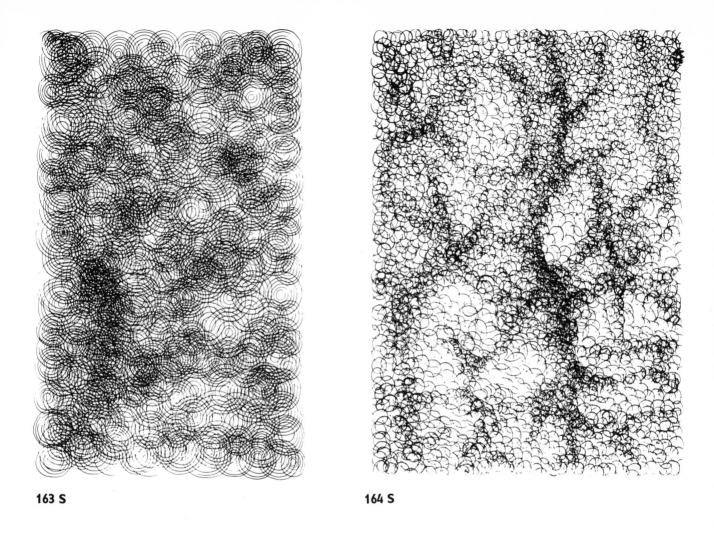

**163 S**

**164 S**

**157-164:** Linear texturing of various types, each exercise limited to the use of a single type of stroke

**161-164:** These exercises were drawn with the aid of compasses.

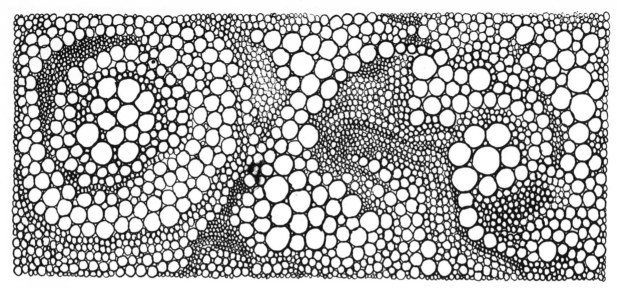

**165 S**

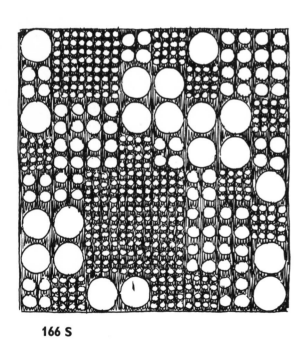

**166 S**

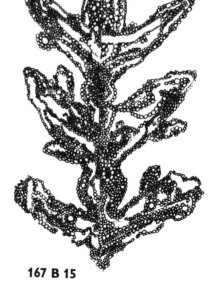

**167 B 15**

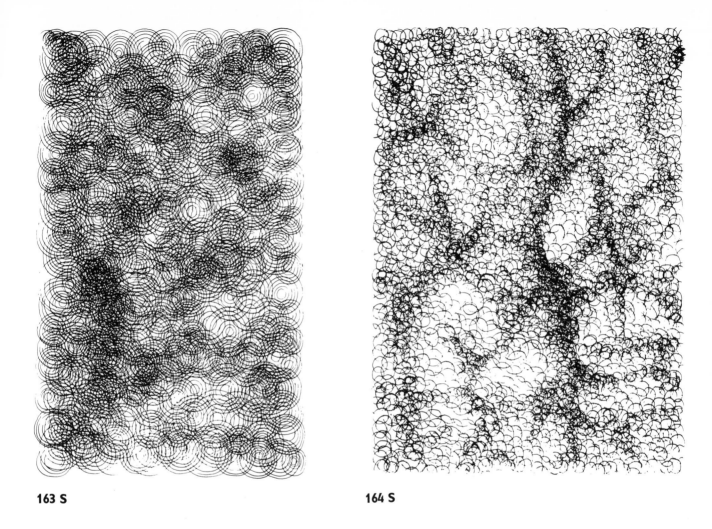

**163 S**

**164 S**

**157-164: Linear texturing of various types, each exercise limited to the use of a single type of stroke**

**161-164: These exercises were drawn with the aid of compasses.**

**165 S**

**166 S**

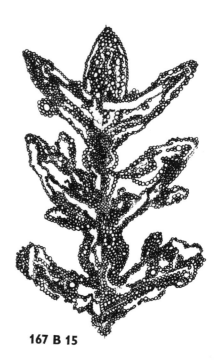

**167 B 15**

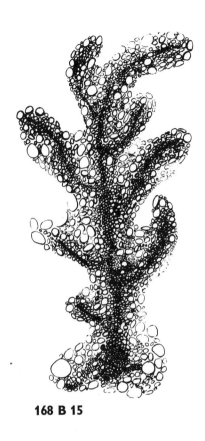

**168 B 15**

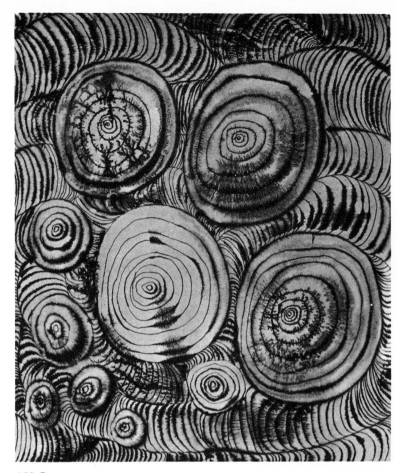

**169 S**

165, 166: Area articulation with circles of varying size, grouped with varying density.

167, 168: Leaf-forms with cellular structure suggested by varying formal density.

169: Ink lines drawn on wet paper blur and ramify into delicate patterns.

All these exercises depend on lively, spontaneously drawn line. Preparatory drawing would be wrong, as it inhibits an unconstrained linear flow and imposes an undesirable rigidity.

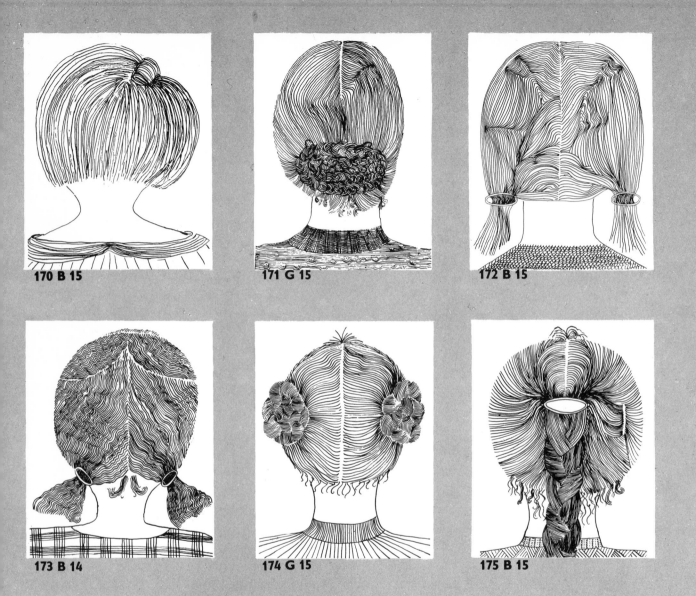

170 B 15　171 G 15　172 B 15

173 B 14　174 G 15　175 B 15

Application of the preceding exercises in texturing to the solution of an exercise in figurative drawing. The pupils were allowed only to pencil in a rough oval for the head and were then made to use pen. This is good disciplinary practice and keeps the drawing lively.

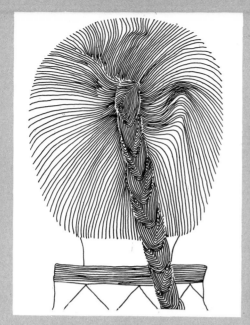

176 B 14

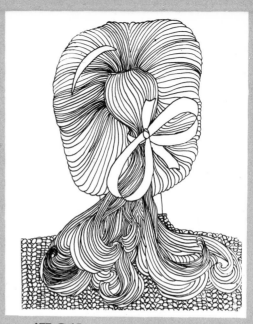

177 G 15

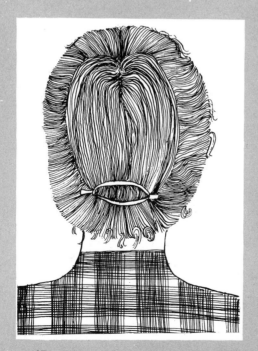

178 G 14

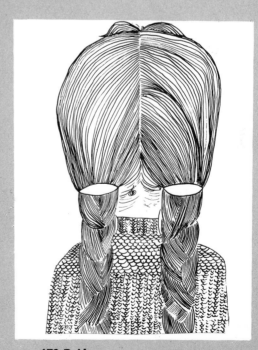

179 B 14

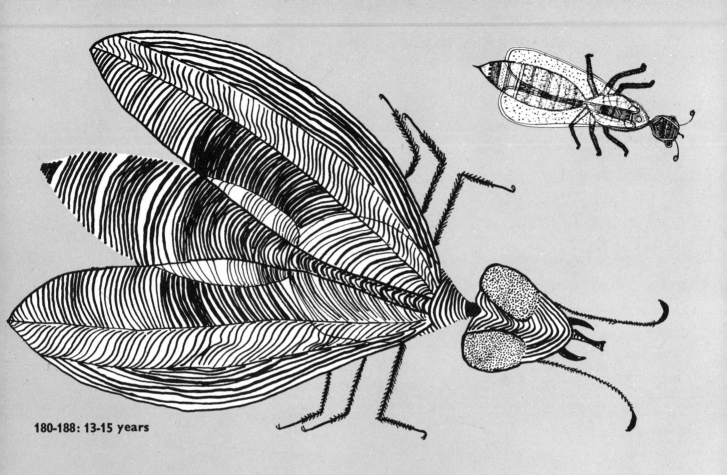

**180-188: 13-15 years**

Pen drawings: 'Insects'.

Here too the use of the pencil was only allowed for drawing the general outlines. The original size of each drawing was from 8 x 11½ to 11½ x 16½ inches.

When drawing this large insect the pupil has let himself be entirely guided by the expressive quality inherent in the medium.

**189-194: Drawings by younger children.**

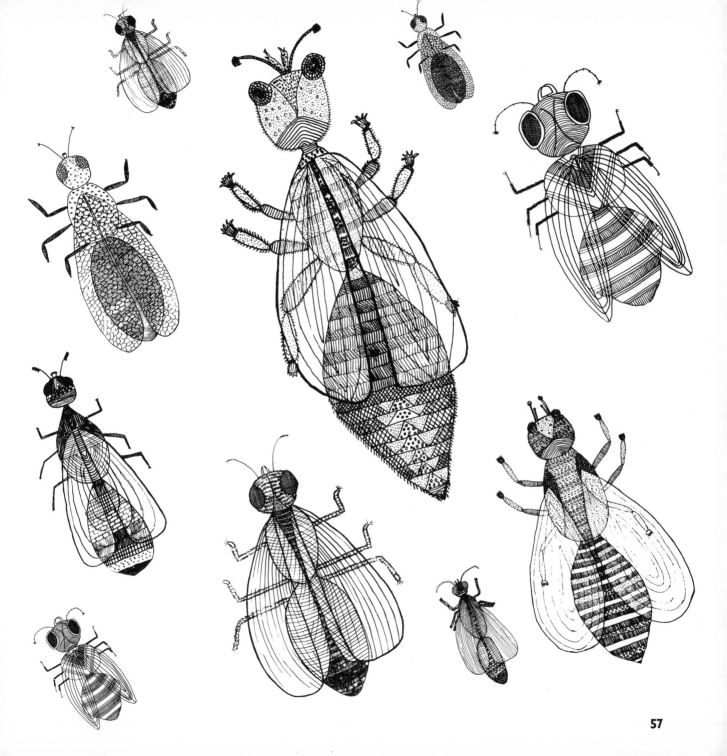

**189 B 11**

**190 B 11**

**191 G 11**

**192 B 12**

**193 G 12**

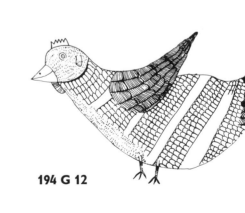

**194 G 12**

58

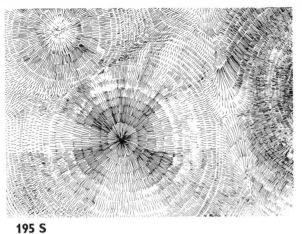

**195 S**

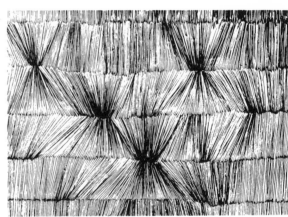

**196 S**

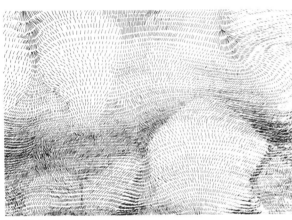

**197 S**

**198 S**

# HATCHED LINE

**195-198: Forms built up from rows of short strokes. Stripes and textured areas ranging in effect from flat to plastic are created by varying the thickness and grouping of the strokes.**

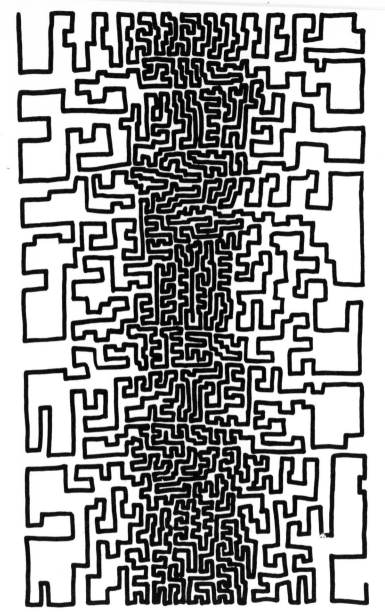

199 S

## UNBROKEN LINE

The line drawn in one stroke without inter-
ruption is to be found in children's games
and adults' party games.

Clearly there is a particular attraction in
keeping up a movement along an uninter-
rupted track.

The exercises on pages 60 - 64 are based on
the use of unbroken line.

199: Using a felt pen, a line was drawn
bending only at a right angle and building
up a denser texture down the centre of the
area without actually touching.

200-205: Figurative exercises in drawing
frost-flowers executed in unbroken line.

Exercises of this kind demand a high
degree of concentration and stamina.

They are good for discipline and enhance
the student's perception of the expressive
power of line. The value of line is literally
'experienced'.

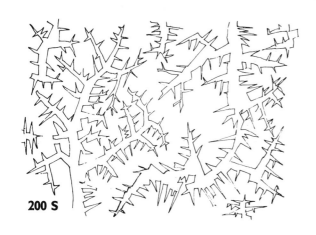

**200 S**

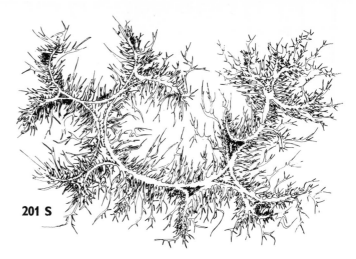

**201 S**

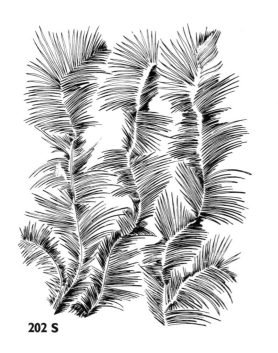

**202 S**

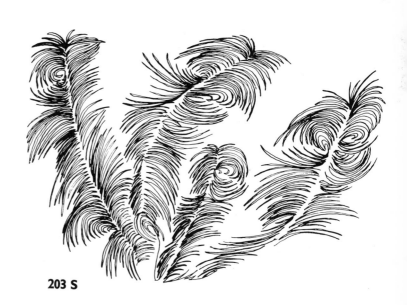

**203 S**

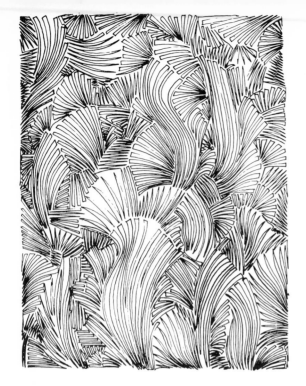

204 S

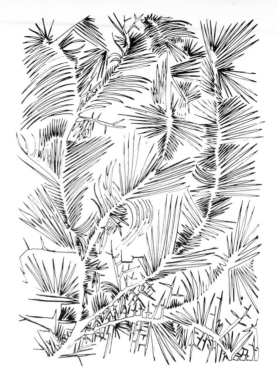

205 S

206-208: Spatial articulation by right-angled and criss-crossing line. In 206 the patterns become slightly denser towards the edges, in 208 they increase in density inwards and form a centre of gravity around the middle. (Original size 24 x 34 inches.)

207: A delicate pattern of unbroken line is built up within a linear framework of vigorous rectangles.

209-212: Bold, large-scale patterns drawn with the full sweep of the arm. (24 x 34 inches.)

213-215: Exercises of a different type. Spatial articulation by rectangles and cell-like forms.

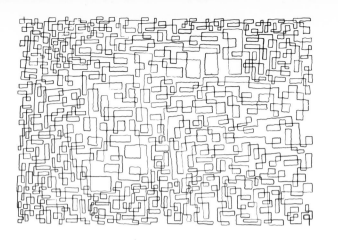

**206 S**

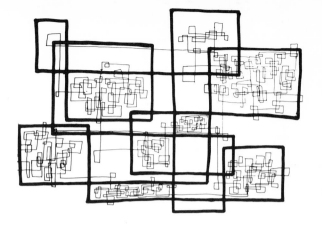

**207 S**

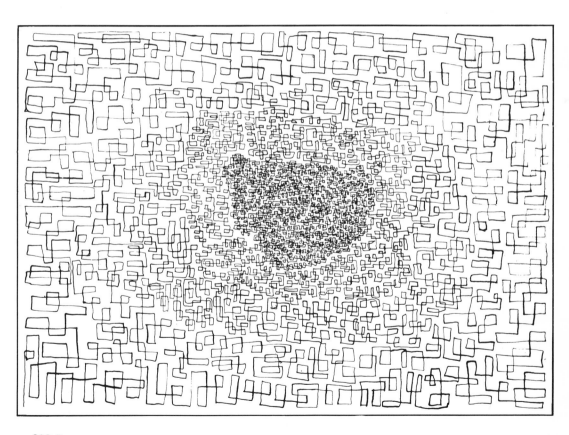

**208 S**

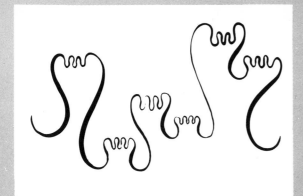

**209 S**

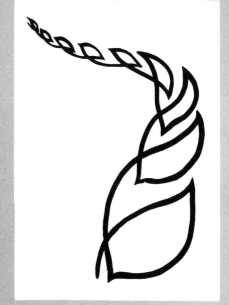

**210 S**

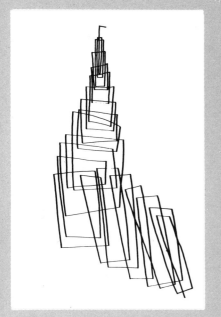

**211 S**

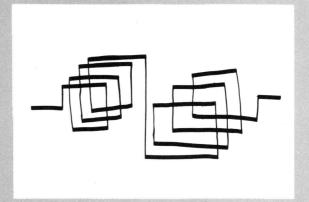

**212 S**

64

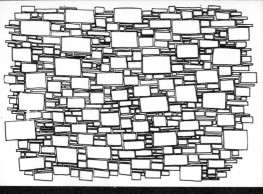

**213 G 14**

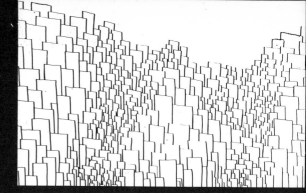

**214 S**

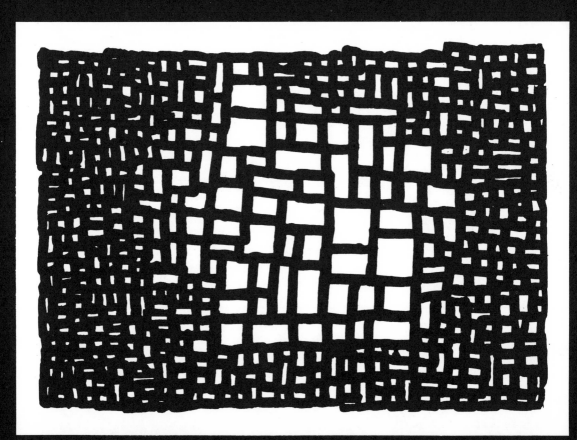

**215 S**

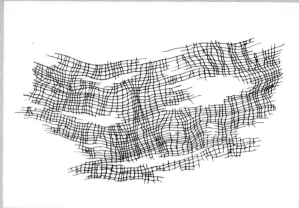

216 S

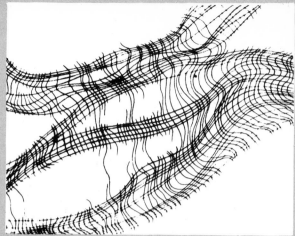

217 S

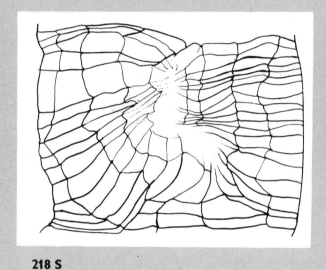

218 S

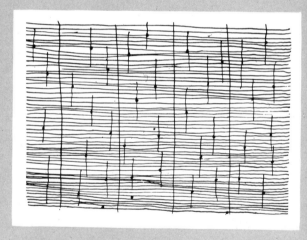

219 S

# BROKEN NETWORK

Linear structures reminiscent of torn weave. Even a form which is destroyed or functionally useless can have great attraction from the pictorial aspect.

220, 221: Free texture in line.

223: Drawing derived from the braces of a suspension bridge.

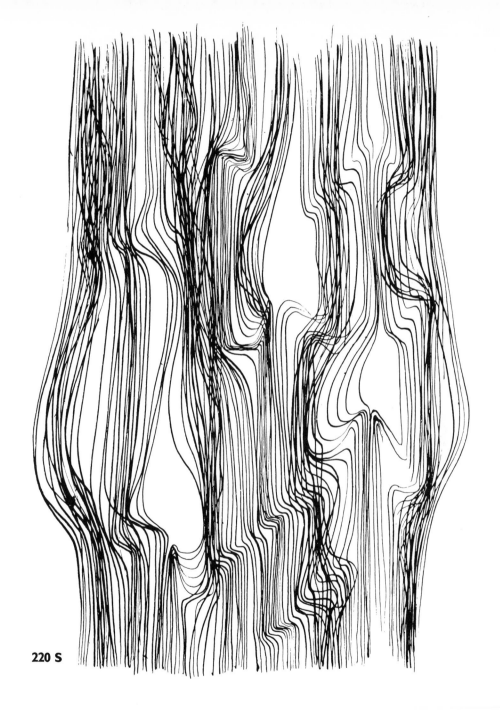

220 S

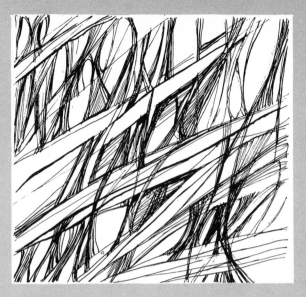

221 S

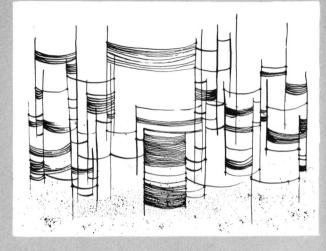

222 S

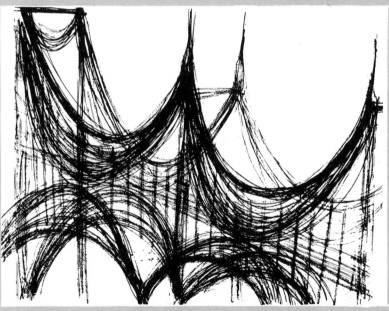

223 G 15

Figures 222 to 229 were drawn to the teacher's instructions; a word on this subject should be said here. As long as children are drawing spontaneously the teacher need do no more than discuss the subject matter that he has set, elucidate ideas and stimulate the imagination. But as soon as the pupils start imitating examples or when later, through a misunderstanding of the idea of creative freedom, they start getting 'arty', the teacher must step in.

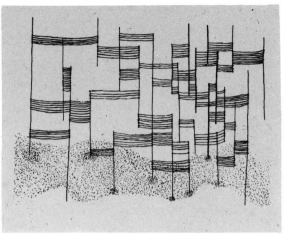

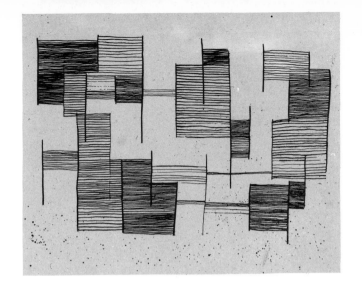

224 B 16

225 B 15

If the experienced teacher does not give a lead, then pupils will take their lead from bad examples. The aim is to avoid pseudo-art and to evoke honest, valid, even if modest, achievement and this requires help and guidance from the teacher. Drawing to order is to be regarded as an aid to method.

'Drawing to order' should never, of course, mean that the teacher executes his own drawings through the medium of thirty children. Every pupil should be given as much freedom as is necessary for carrying out the work alone. Even if the exercise is begun in collaboration, the pupils will soon learn to proceed independently within the set framework so as to arrive at a completely individual solution. Since, when drawing to order, they begin by being unaware of the final aim, they are correspondingly free of preconceptions and will draw entirely in accord with the dictates of the pictorial medium, which is the precise intention of drawing to order. 222-225: Detailed sequence of an exercise in drawing to order. A vertical stroke of half the width of the sheet in length is drawn on the left-hand side of the sheet, then another of equal length on the right-hand side and a shorter one in the middle. Now the sheet is further freely articulated with 10 to 25 vertical strokes of varying length. When this has been done the drawing to order continues.

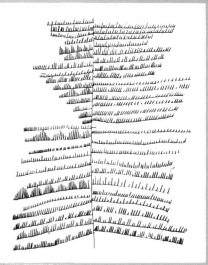

226 G 5

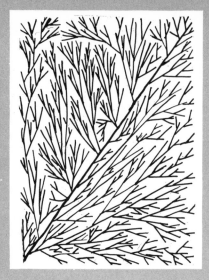

227 B 11

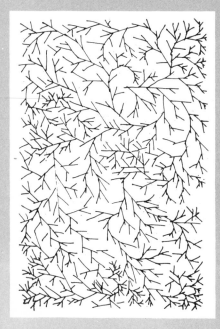

228 B 18

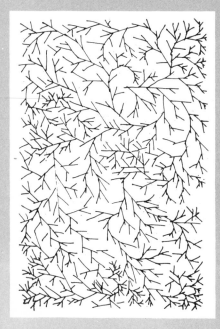

229 S

The upper end of the left-hand stroke is then joined to the next stroke by a slightly sagging horizontal line, followed by second, third and fourth lines parallel to it. In this way all the verticals ('poles') are joined by horizontals ('cords') until a balanced articulation of the whole surface has been achieved. The 'Ground' may then be indicated by random dots.

Figures 226-229 illustrate a process which is found everywhere in nature - branching out. The tree branches from the trunk to the thinnest outer twigs; a leaf is built upon the same system. In the reverse, rivulets flow into a stream into a river. The delicate ramifications of the body's nervous and arterial systems are based on a similar structure.

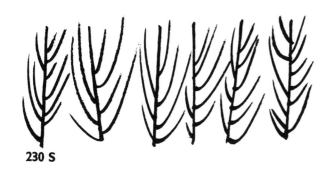

**230 S**

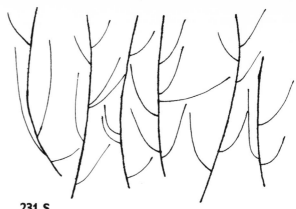

**231 S**

**232 S**

**233 S**

**234 S**

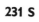

**235 S**

**236 S**

**237 S**

**238 S**

**239 B 14**

226, 227: Here exercises in drawing to order were tried with younger children, a five-year-old and an eleven-year-old boy, both with surprisingly good results.

230-240: Linear-based plant forms.

**240 G 14**

**241 B 14**

**242 B 13**

230-232, 235, 236, 238: Plants as a basis of a study in rhythmically contrasting forms. Crossing and overlapping lines have been avoided.

241, 242: Feathers.

243 S

244 S

245 S

246 S

**243-246: Various solutions of an exercise on the theme 'A group of tables and chairs'.**

**247: A lively example of loose linear rhythms.**

**248: A sensitive interpretation in line of plant growth and the movement of water.**

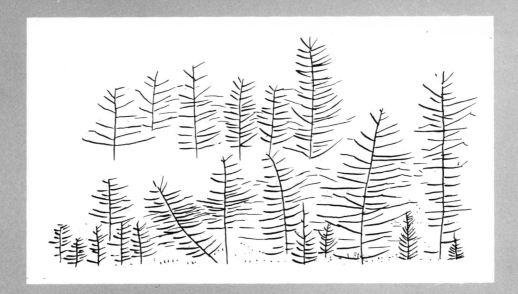

247 S

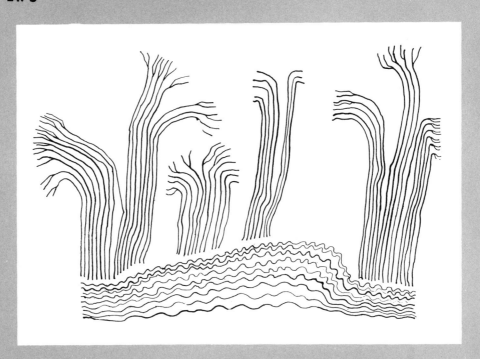

248 S

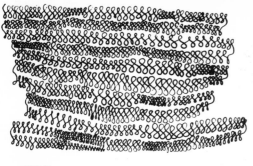

249 S

250 S

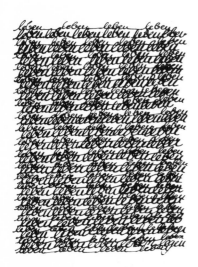

251 S

252 B 15

253 S

# SCRIPT AS RHYTHMIC LINE

Script represents a linear discipline of a special kind. Here, freed of its usual purpose, it is to be used as a purely formal linear texture and the following exercises should be seen as such. The progression moves from free play with single letters through spatial articulation with words to conscious design with script. A few examples are given as suggestions.

249-251: Linear compositions made up from one word or one letter written as continuous script.

254: Pattern of juxtaposed block capitals in various sizes. Here too the lettering is used purely as a pictorial element.

255: Subject matter and structure combined into a pattern.

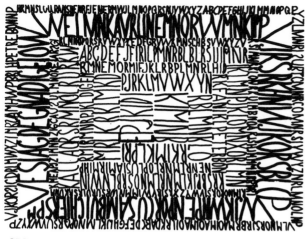

**254 B 12**

**255 B 12**

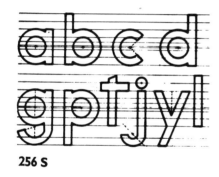

**256 S**

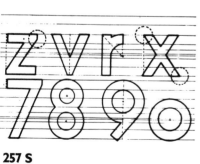

**257 S**

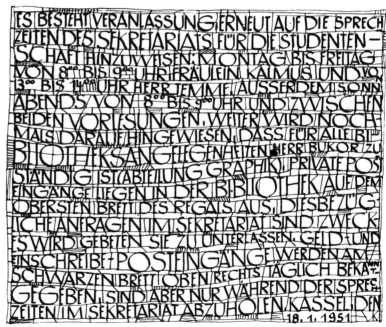

**258 S**

256, 257: Lettering as design.

258: Writing as decorative patterning.

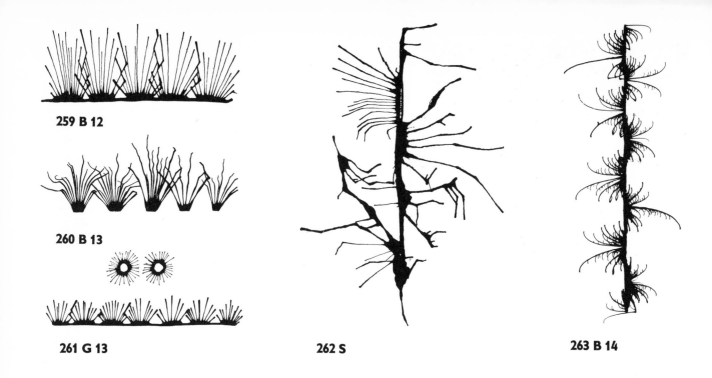

259 B 12

260 B 13

261 G 13

262 S

263 B 14

# BLOWN LINES

A thick line is drawn on the paper with India ink. By blowing sideways at the line the ink runs over the paper at random, producing bizarre patterns. What at first seems to be an aimless blur becomes quite controllable after a little practice. If a drinking straw is used for blowing, the stream of air is concentrated and easily aimed. Patterns can be influenced in many different ways - the distance of the straw from the paper, the angle at which it is held, blowing straight, crooked, evenly or in bursts or by moving the tube. The best way of exploring the possibilities is to begin by free experimentation, then the results achieved by chance should be brought under control and used consciously. The few illustrated examples show the enormous potential variety. Formal patterns of this kind have a unique character which is quite unattainable by drawing. If colour is also employed the number of possible combinations is greatly increased. The blowing method requires a high degree of discipline unless the whole thing is to lapse into pointless triviality.

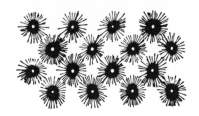

**264 B 13**

**265 G 13**

**266 G 13**

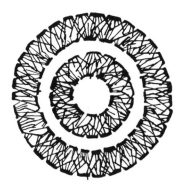

**267 G 14**

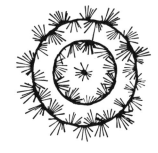

**268 G 13**

**269 B 13**

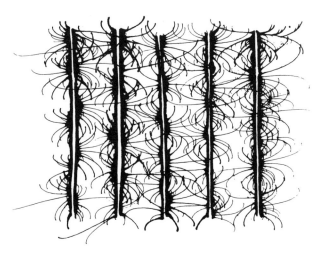

**270 B 14**

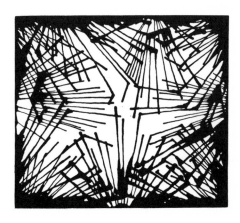

**271 B 14**

79

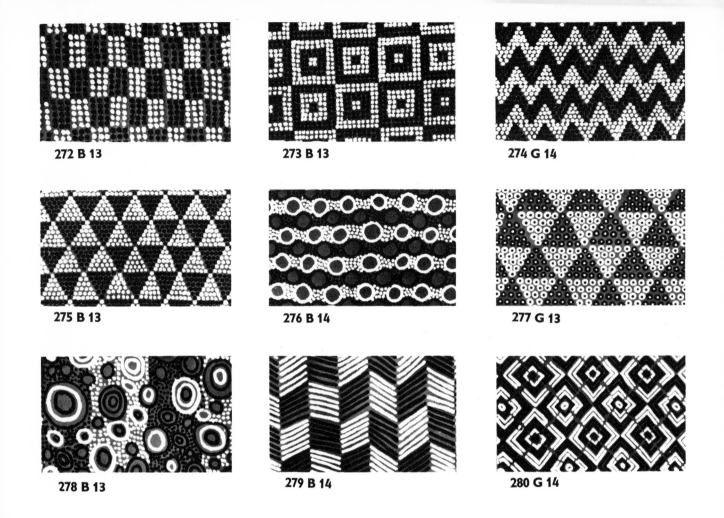

272 B 13    273 B 13    274 G 14

275 B 13    276 B 14    277 G 13

278 B 13    279 B 14    280 G 14

# POINT AND LINE IN SHADES OF GREY

These examples of children's work show exercises in black and white India ink on grey paper. The tools required are two pens with lettering nibs of 3/16 to 1/4 inch in width, one for black and one for white. The points are simply produced by a dab of the nib.

272-275: Strictly ordered patterns made up of points.

276-278, 281: Point and circle patterns in strict order, in 278 more at random.

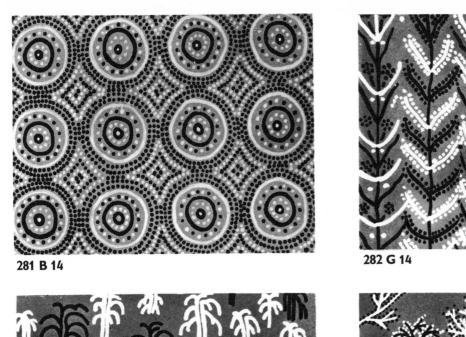

281 B 14

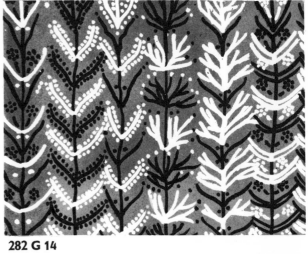

282 G 14

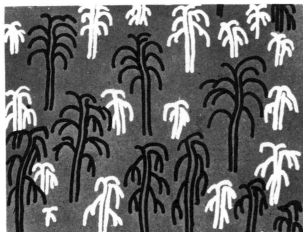

283 B 13

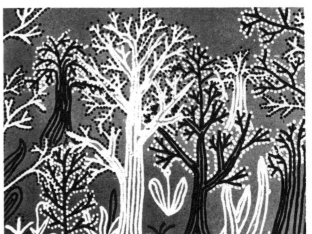

284 B 13

279, 280: Patterns made up of simple diagonal strokes and angles.

281: Mosaic effect. The circles are drawn freehand: the slight irregularities enhance the liveliness of expression.

282-284: Patterns with plant-like motifs. A pictorial effect has been achieved in 284.

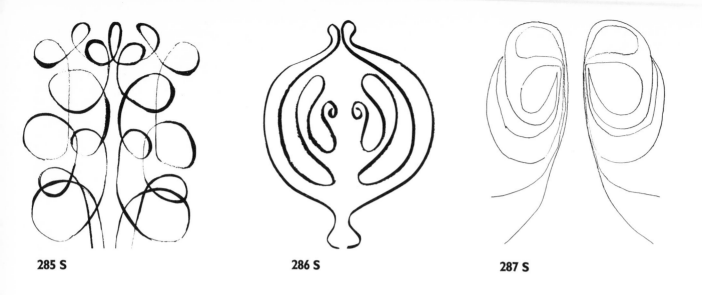

285 S          286 S          287 S

## TWO-HANDED LINE DRAWING

Two-handed drawing could be called 'graphic gymnastics'; its aim is relaxation and liberation of movement. Like all gymnastics, however, it can only be effective if it is practised regularly and often. The pupil stands in front of the wall, the easel or the blackboard, the drawing surface so arranged as to allow the full reach of the arm to be used. Drawing with both hands involves the whole body and should be done in time to the rhythm of breathing. If the movements start at the same point and are carried out in the same way, symmetrical forms will result, whereas asymmetrical forms are produced when the two hands start at different points and move in opposing directions. The best instrument is a thick pencil, charcoal, chalk or paint-brush. The pattern of movement in two-handed drawing should be laid down and carefully controlled. All the drawings illustrated here are at least four feet high in the original; 290 is five feet three inches wide.

289: Two hands tracing independent and opposing paths.

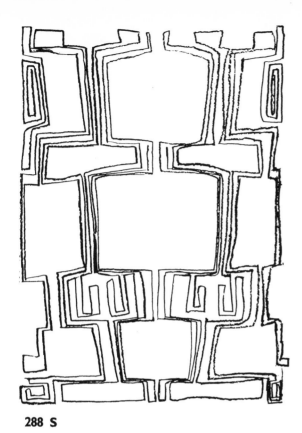

**288 S**

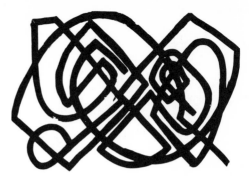

**289 S**

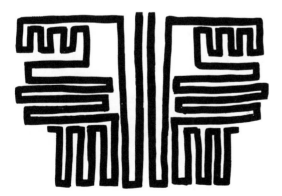

**290 S**

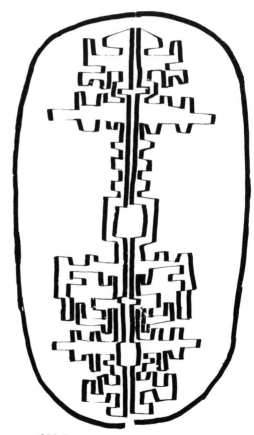

**291 S**

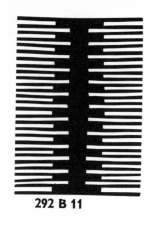

**292 B 11**

**293 G 12**

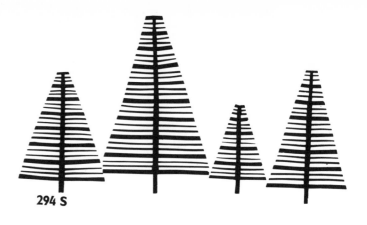

**294 S**

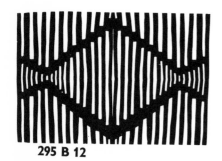

**295 B 12**

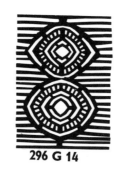

**296 G 14**

**299 G 13**

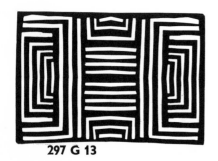

**297 G 13**

**298 A**

**300 A**

**301 A**

**302 A**

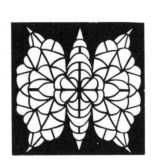

**303 A**

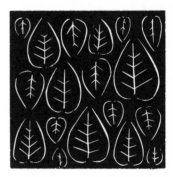

**304 A**

## CUT-OUT LINE

The contrast of black and white surfaces is usually regarded as the typical feature of cutting out. Here is shown a style of cutting out in which line is the vital element.

292-299, 303: Severe linear patterning achieved by cutting across single and double folds. Since fold-cutting produces symmetrical forms it is relatively easy to produce good results.

300, 301: Freehand cutting from a flat sheet is more difficult.

320, 304: Note the completely different effect achieved by line cut in negative.

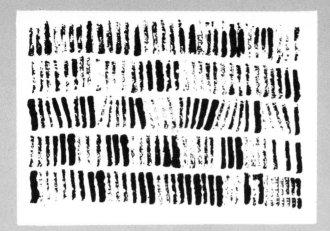

305 S

306 S

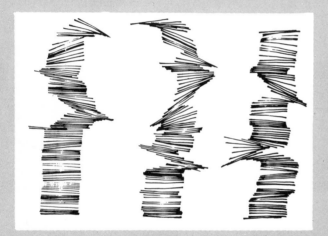

307 S

308 S

## STAMPED LINE

The characteristic of a stamp is that it always prints the same shape, which can only be slightly differentiated by the number of colours which may be employed. Thus stamped work has its limitations and direction imposed on it by the tool itself and the pictorial element derived from it.

Line too can be printed by means of an appropriately cut stamp. All the work illustrated was produced by a strip of cardboard dipped in water colour and impressed on absorbent paper.

Only one stamp was used for each exercise.

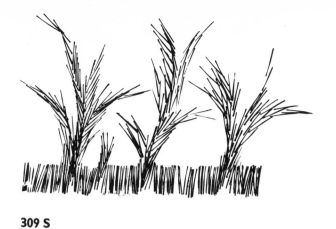

309 S

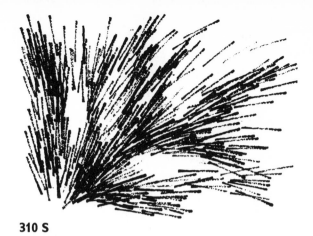

310 S

311 S

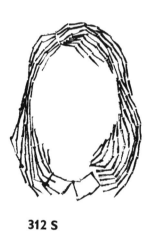

312 S

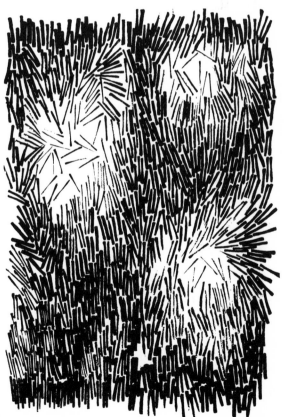

313 S

305-308: Linear sequences built up in rows.

309-310: Forms based on growing plants.

311, 313: Triple groupings arranged in positive and in negative.

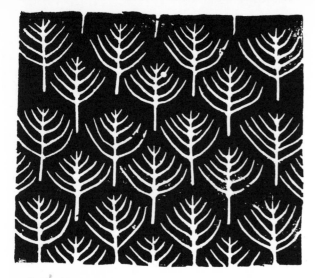

314 G 12

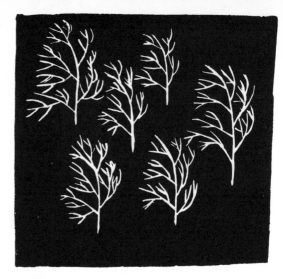

315 B 13

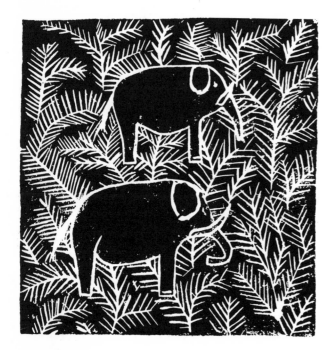

316 B 12

## INCISED LINE

Lino-cuts and woodcuts are probably the best known and most used methods of printing, especially lino-cutting. As it is relatively easy to execute it can also be undertaken without difficulty by children.

Linoleum offers considerable resistance to the cutting edge, so that line incised in this way is necessarily more severe in character than drawn line.

317 S

In woodcuts line is even more strongly determined by the material. Wood is not only harder, but in contrast to the uniform consistency of linoleum it also has an organic structure.

The exercises shown will be limited to line cut in negative. It is more effective than positive line which can only be cut out with considerable effort and the results are nearly always disappointing.

It is not advisable to go into detail with preparatory pencil drawing. A line that is drawn is very different from an incised line; on the other hand there is no objection to sketching in a general layout with pencil. However the best method is freehand cutting, as in the case of the examples reproduced here.

314-316: Lino-cuts. Good solutions to exercises of carefully limited scope.

317: Woodcut. A good example of how the most restrained use of the medium produces a satisfying results.

318 B 13

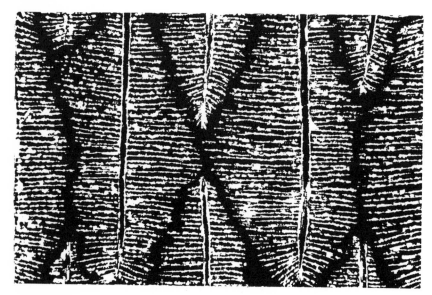

319 G 14

## SCRATCHED LINE

A line is scratched with a needle in black poster cardboard, so that the card beneath the coloured layer is exposed. The thin fibres of the cardboard are easily pulled loose, creating a line of irregular thickness. As the illustrated examples show, line produced by scratching has a strongly picturesque character.

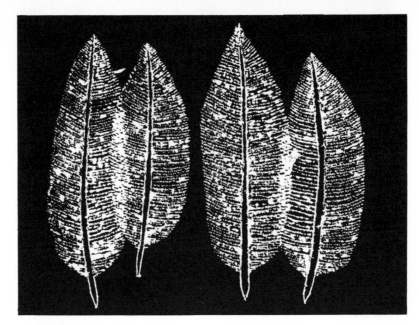

320 B 14

Poster cardboard, which can be bought commercially, is the best material for these exercises, but heavy board or light card can be prepared by applying a layer of colour over the surface. Care should be taken, however, that the colour - poster colour is the best - contains very little water so that it only remains on the surface and does not penetrate the whole thickness of the cardboard.

321 G 14

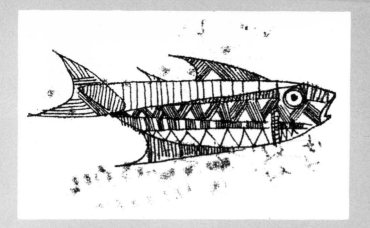

322 S

# MONOTYPE

A sheet of drawing paper is laid over a piece of board or a sheet of glass which has been covered in printer's ink by roller. The drawing is executed on the upper side of the sheet. Through the pressure of the pencil the colour is picked up on the underside and a line results. When the drawing is finished the sheet is pulled off the underlay.

With monotype the pencil is not the only possible tool. The blunt end of a pen-holder, a match, even a fingernail can be used to draw with. The character of the drawing can be effectively influenced by the use of different tools. Soft, blurred effects from pale grey to black can be produced by pressure or rubbing with the finger.

323: A striking contrast between plant-like and crystalline forms.

324-327: Four solutions of the exercise 'Head with veil'. The drawing was intended to incorporate various gradations of grey.

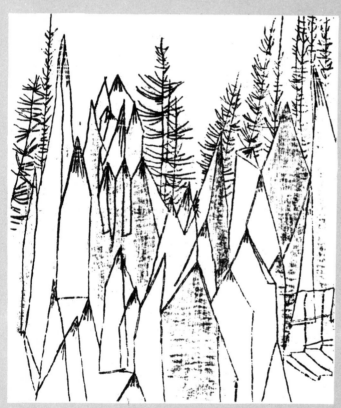

323 S

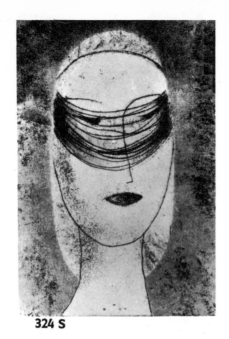

324 S

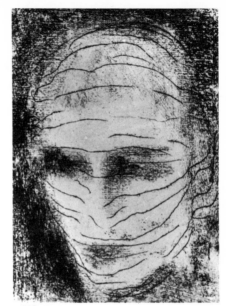

325 S

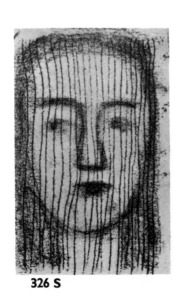

326 S

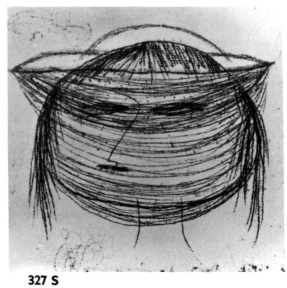

327 S

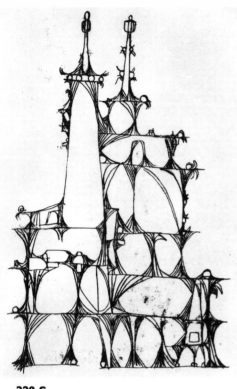

**328 S**

**328: Linear pattern in the form of a building**

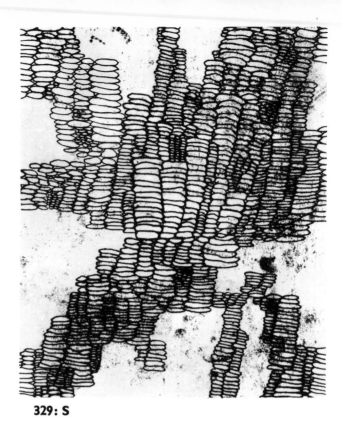

**329: S**

**329: Loose serial grouping of simple forms**

# TEXTURE IN POINT AND LINE

A pattern cut-out of paper is pinned firmly to a sheet of white drawing card. Colour is blown on with a fixative spray. A dense or loose texture of dots is produced according to the intensity of the spray. The area covered by the paper pattern stays white. If several patterns are used and laid on and removed in succession during spraying, the result is areas of varying point texture (see Fishes, Figure 331).

Figures 330 to 336 show combinations of point-and-line textures. After spraying, the appropriate linear patterns were drawn in the white areas by freehand penwork.

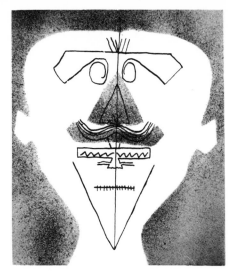

**330 B 11**

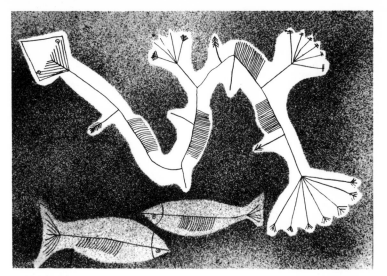

**331 B 13**

**332 B 14**

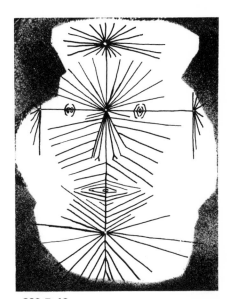

**333 B 12**

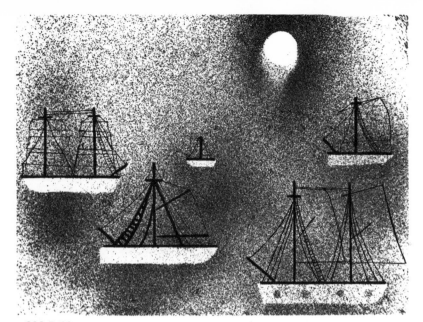

334 B 12

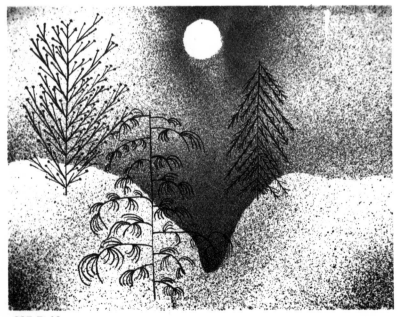

335 B 12

Particularly where children's work is concerned it is important not to be satisfied with the first paper pattern that comes to hand or with one sheet of drawing card. First a number of patterns should be cut out of newspaper or wrapping paper and then that one selected which in size and shape best fits the given surface. Using this pattern a series of sheets should be prepared by spraying so that several are available for drawing on; wherever possible exercises should be so planned and prepared as to afford the widest scope for practice.

334: 'Ships in the fog.' First the sun and the ship's hulls were covered by pattern paper, then the children were allowed to 'make a fog' with the fixative spray, after which the rigging was drawn in by pen.

335: 'Trees in the fog.' Produced in the same way as 334.

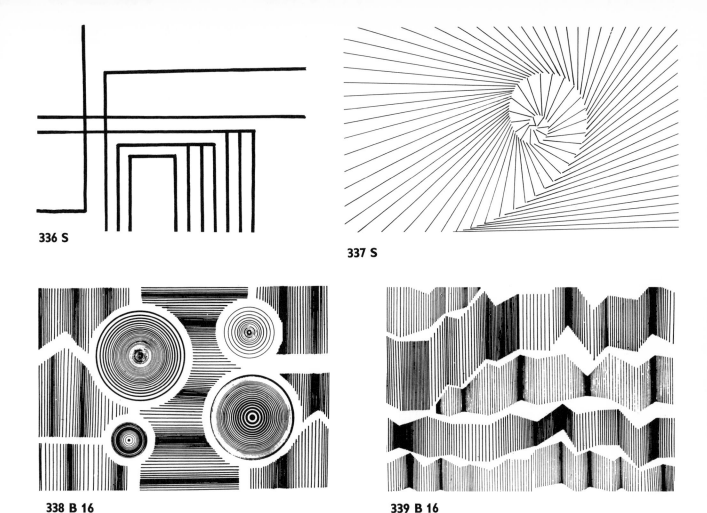

336 S

337 S

338 B 16

339 B 16

# LINE DRAWN WITH RULER AND COMPASS

This type, due to its firm structural character, produces a marked effect of orderliness.

336, 337, 340: Exercises in purely linear, two-dimensional expression.

338, 339: The rows of short strokes with intervals of various sizes produce the effect of plastic, indented bands.

341, 344: Linear construction with strongly plastic effect.

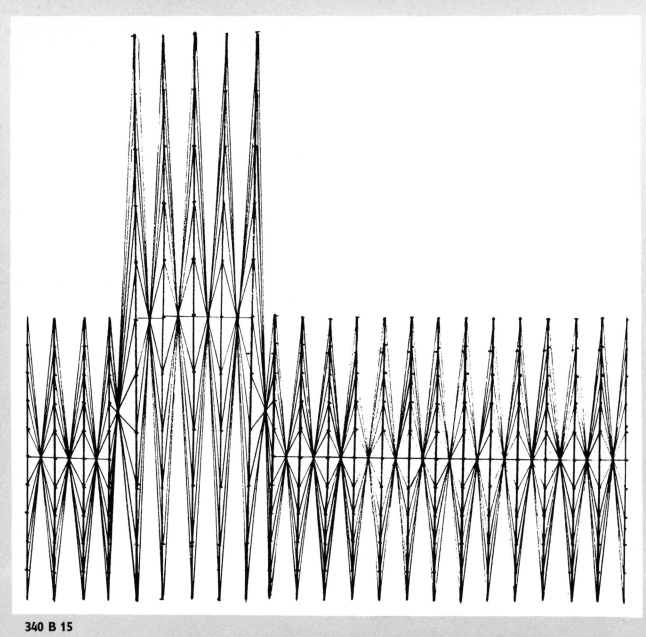

340 B 15

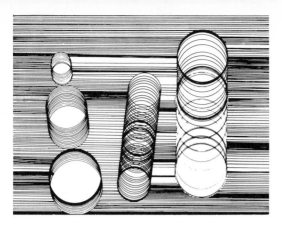

341 B 15

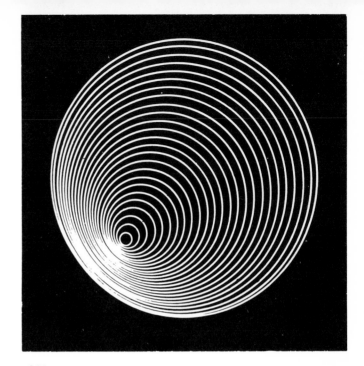

342 B 16

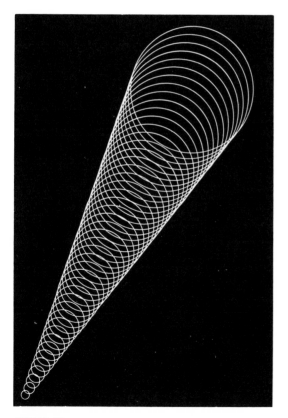

343 B 16

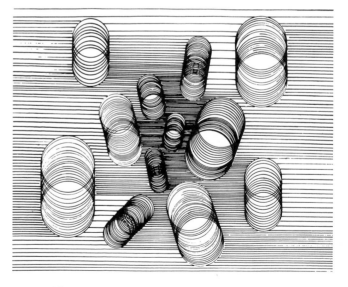

344 B 15

99

# FIGURATIVE DRAWING FROM THE IMAGINATION

In figurative drawing the lines are usually made to enclose flat or plastic forms. In doing so they should not however lose their linear expressiveness. Therefore drawings to represent solid bodies should avoid trying to achieve plastic effect by shading.

345: A still life drawn by the 'drawing to order' method.

346: Detail of drawing built up on similar lines to 345.

347, 348: Apples and pears as plastic shapes in contrast to the flat effect of basketwork textures.

349-351: Linear expression of the contrast between natural and artificial forms.

353, 355: Pen drawings in white India ink on a black ground with both flat and plastic effects.

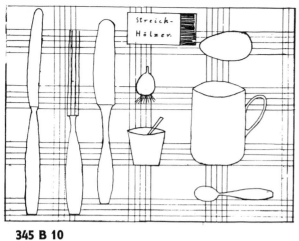

**345 B 10**

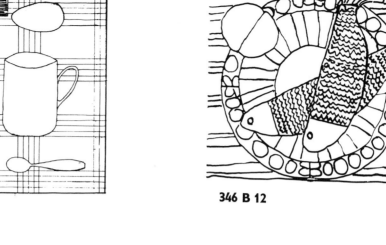

**346 B 12**

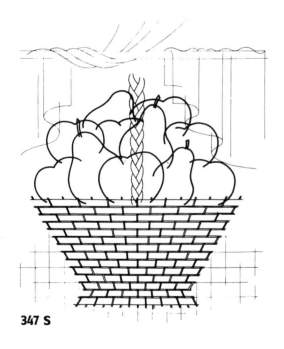

**347 S**

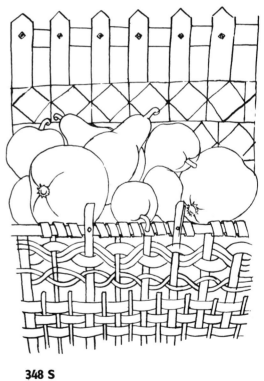

**348 S**

349 S

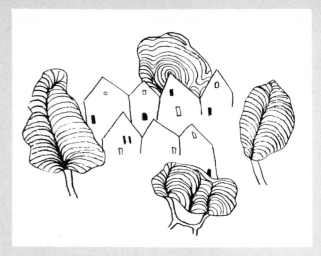

350 S

351 S

Drawing to achieve plastic effect is foreign to the small child. He draws things as if they were flat, from the front, from the side or from above according to which aspect is typical, and will cheerfully combine several aspects. It is advisable to try to maintain as long as possible this healthily naive way of drawing, but when children of their own accord start to draw solid bodies with plastic effect and struggle with representation in perspective, we should not suppress this move but help the child to practise suitable exercises in three-dimensional drawing.

**352 G 13**

**353 B 13**

**354 B 10**

**355 B 14**

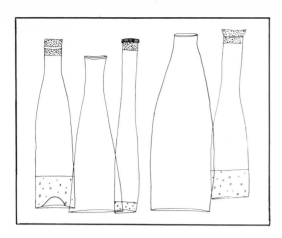

**356 B 14**

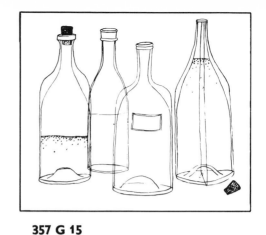

**357 G 15**

**358 G 13**

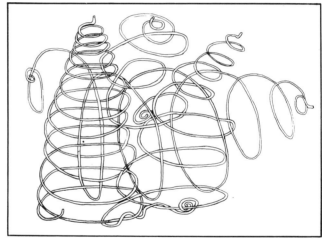

**359 G 14**

Even when drawing 'in the flat' an effect of depth is achieved by overlapping. The shape in the foreground partially covers the object in the background (see Figure 353). The way to begin is by simple overlapping, then proceed to draw simple bodies including even the parts hidden from view. With transparent bodies such as bottles and glasses this occurs in any case. Quite easy exercises are those concerned with building up shapes from cubic bodies.

Figures 356-358 are freehand pen drawings. With Figures 359-363 a rough layout was sketched in beforehand in pencil.

**104**

360 B 14

361 B 13

362 G 14

363 B 14

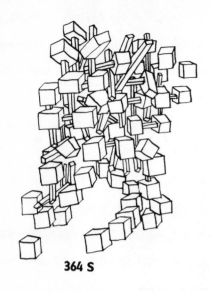

**364 S**

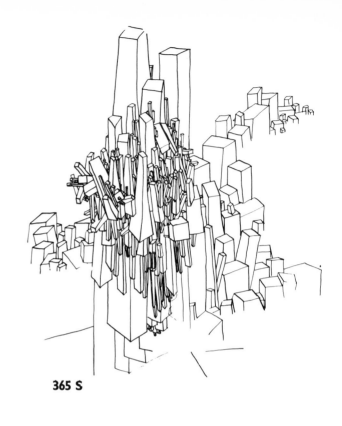

**365 S**

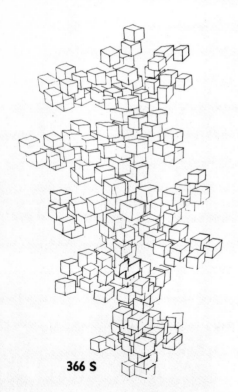

**366 S**

364-368: Spatial compositions of cubic bodies, drawn freehand.

366: A rhythmically balanced spatial composition built up of simple blocks of equal size.

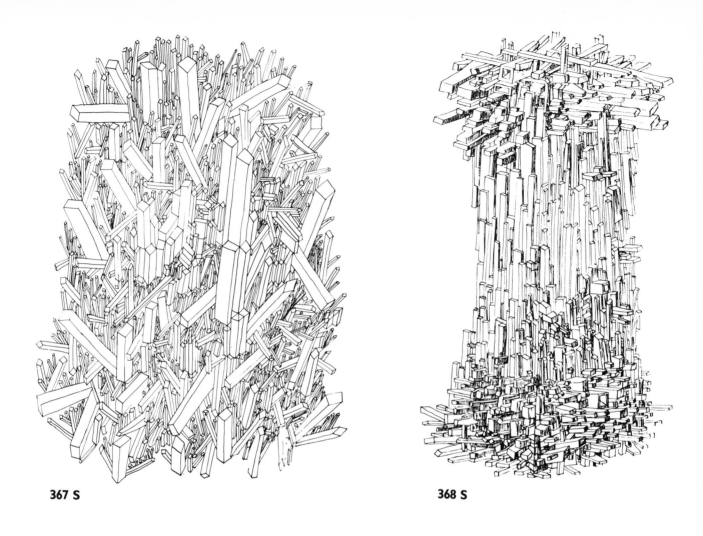

**367 S**

**368 S**

**365, 367:** Spatial composition of bodies of contrasting size.

**368: A** pattern of cubic bodies on three levels.

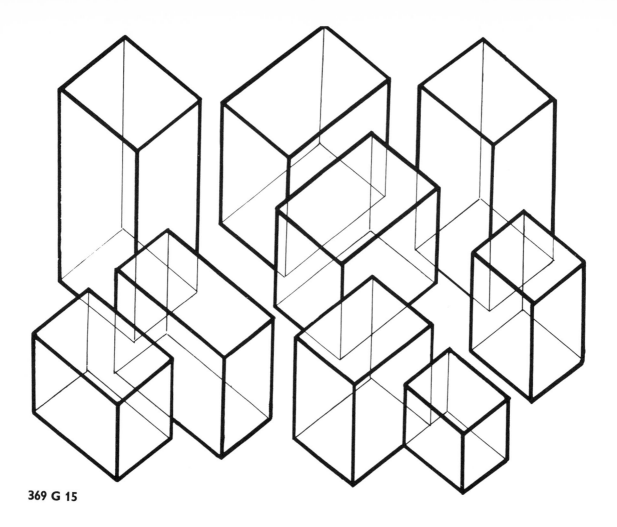

369 G 15

# LINE IN PARALLEL PROJECTION

Of the various types of projection a few examples of parallel projection will be sufficient for this book. To draw cubic bodies in parallel projection is comparatively easy, as there are only three possible directions of line and it is made even simpler if the paper is prepared by being ruled out on a grid, as has been done in Figure 373.

369: Composition with transparent cubic bodies.

108

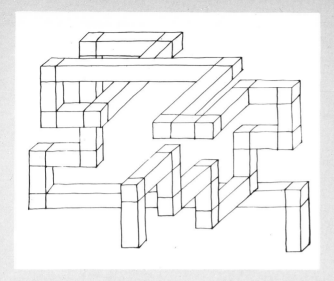

370 S

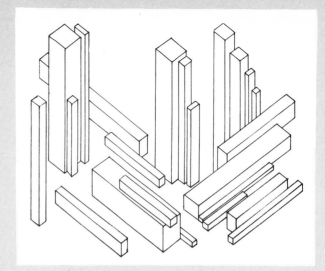

371 B 15

372 S

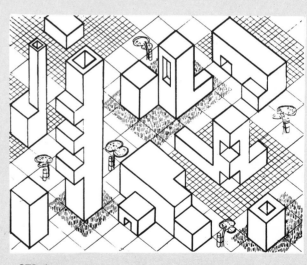

373 S

370: A pattern of beams built up by using two templates (patterns) of different sizes.

371: Composition of standing and lying bodies.

372, 373: The strict, formal character of these exercises is relieved by the introduction of stylised plant-forms.

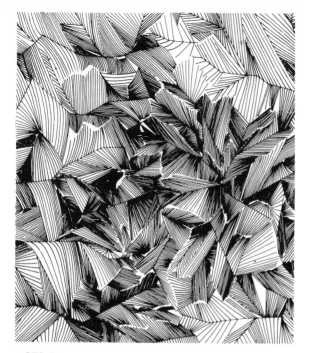

**374 S**

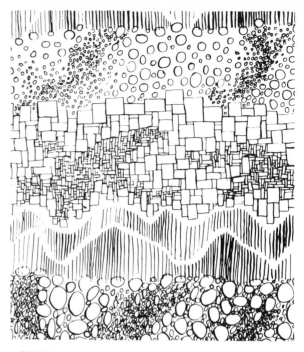

**375 S**

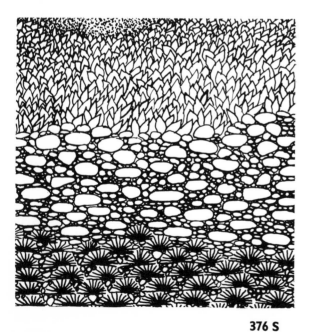

**376 S**

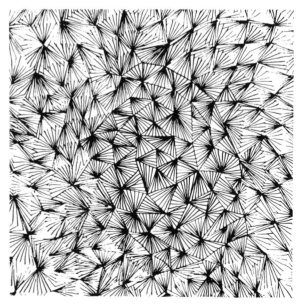

**377 S**

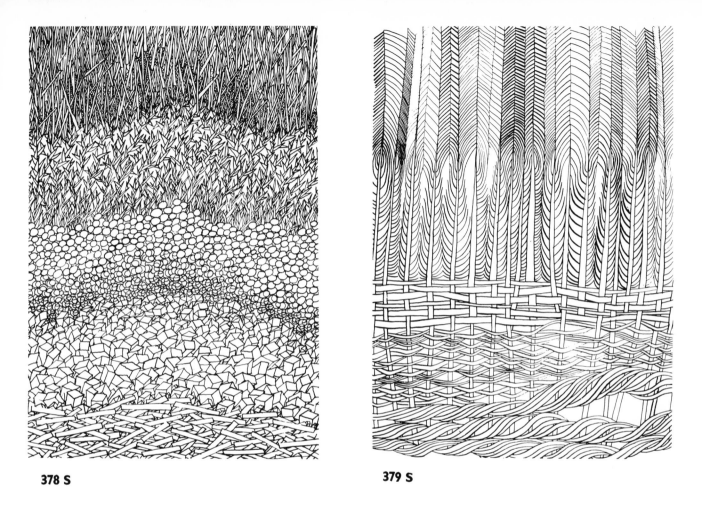

378 S

379 S

## STUDIES IN TEXTURE

The rhythmic juxtaposition of related forms produces linear patterns which are similar to patterns and textures found in nature.

377: One basic linear pattern (fan-shaped rays) is spread out in all directions to produce an animated design.

374: The same exercise. Here the basic pattern is a simple one of stem and branches. The middle is emphasised by closer placing of the 'branches'.

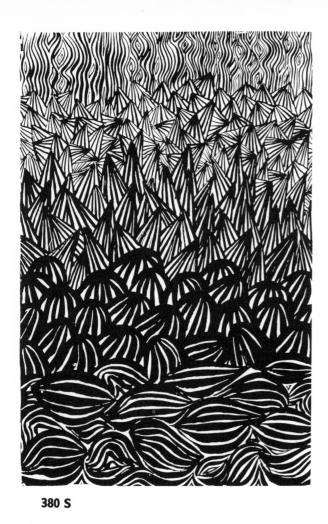

380 S

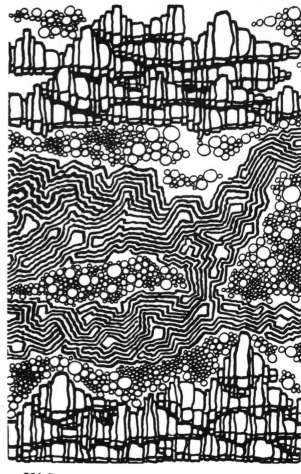

381 S

**375, 376, 378-383:** Different forms of texturing in several juxtaposed zones. In accordance with the types of formal patterns found in nature, these exercises were aimed at producing linear designs whose component groups are graphically self-sufficient. They were suggested by natural forms such as plants, stones, sand, pebbles, sediment, water and artificial forms such as masonry, paving, fencing, basketwork.

**Figures 378-383** illustrate some particularly succesful results.

**384:** Here the exercise is extended into a formal graphic composition.

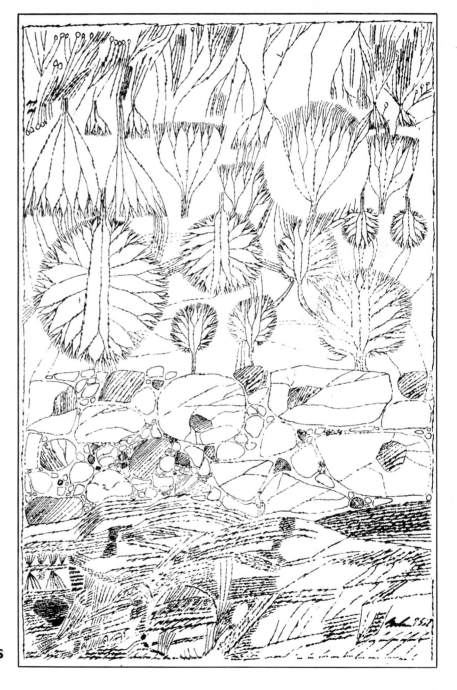

**382 S**

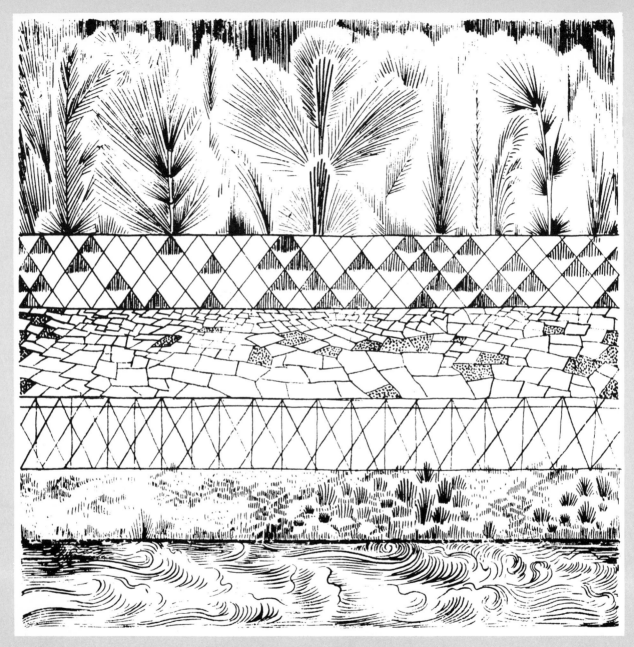

383 S

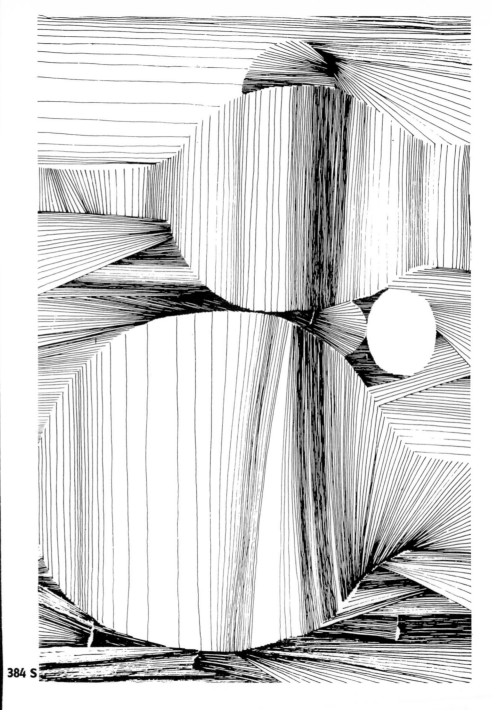

384 S

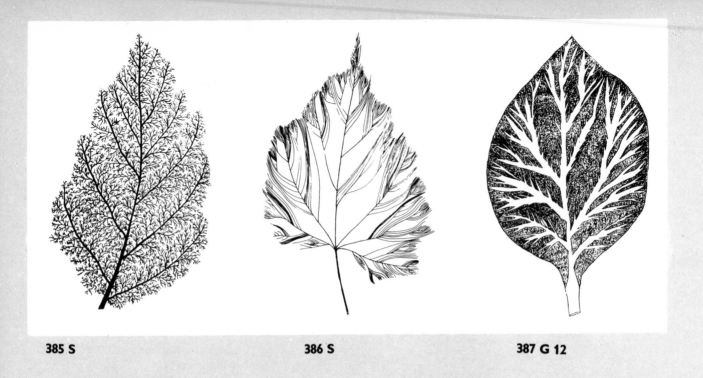

385 S            386 S            387 G 12

## STUDIES FROM NATURE

The reproduction of optical phenomena with all their irregularity was the aim of the naturalistic approach to drawing from nature. Photography has taken over this task and done it much better.

Today less interest is shown in the form itself than in the process of its creation. Paul Klee says: 'We are not concerned with forms as end-products but with formative forces.'

Studies from nature carried out in this spirit will not only teach pupils to see and comprehend the boundless variety of form and the forces at work in nature, but will also inspire them to original creativity.

385-390: Growth and cell-formation in a leaf.

391: Example of a free combination of natural forms. The holes eaten in a leaf by caterpillars were multiplied in drawing and introduced as an effective formal component. A section of the leaf's surface is reminiscent of an aerial photograph of a lake-dotted landscape.

116

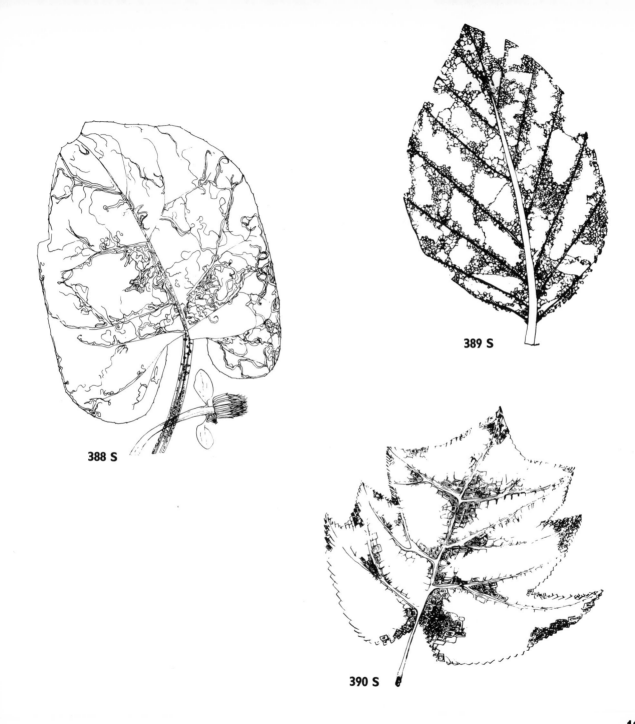

388 S

389 S

390 S

117

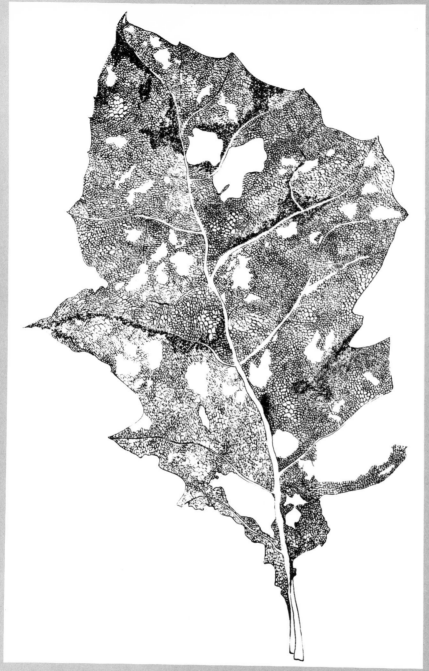

391 S

**392 S**

**393 B 15**

**394 B 14**

**395 S**

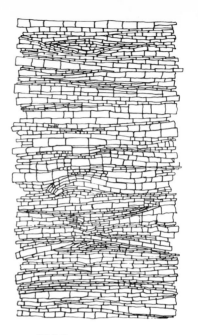

**396 S**

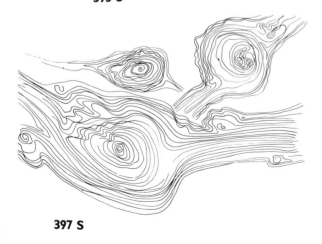

**397 S**

**398 S**

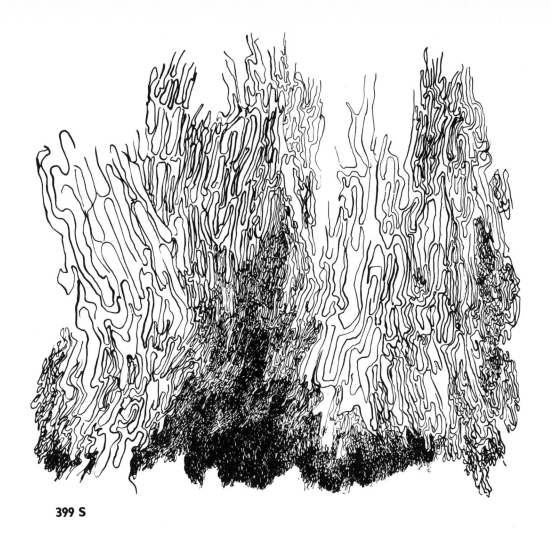

399 S

**395-399: Natural forms reinterpreted as rhythmic line.**

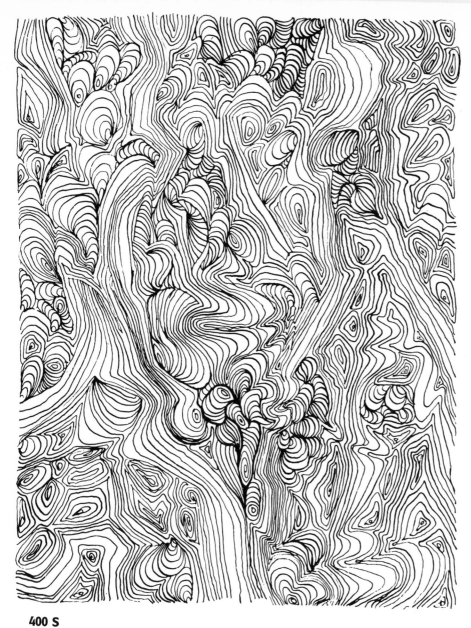

**400 S**

**400:** Free linear composition based on observation of the structural forms of organic matter.

**401, 402:** Studies from nature drawn by pupils at the seaside.

122

401 B 14

402 G 14

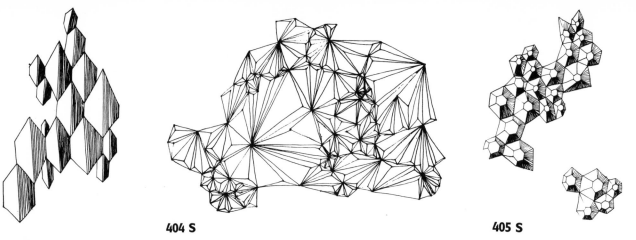

**403 S**

**404 S**

**405 S**

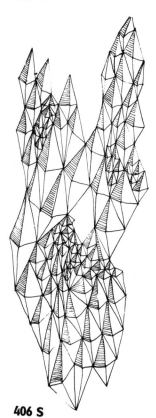

**406 S**

**407 S**

Crystalline forms. Drawn from previous observation.

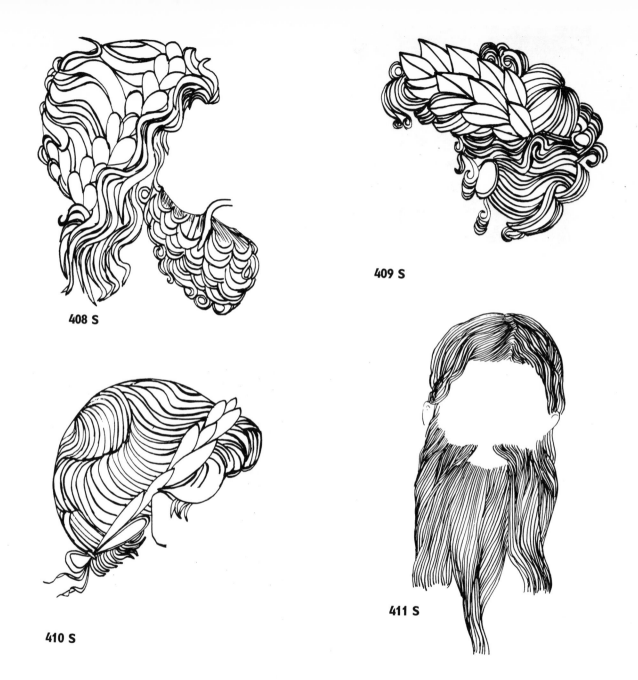

408 S

409 S

410 S

411 S

Antique and mediaeval hair styles as subjects for purely linear reproduction.

125

412 B 12

413 B 12

Two self-portraits drawn in the mirror which, whilst equal in quality, illustrate different conceptions. Both examples typify the purely linear expressive power of children's drawing.

414 S

415 S

Intensive practice in the spirit of the foregoing exercises develops skill in rapidly putting down what one sees and fixing it in lively sketches. Drawings of this quality, of course, presuppose a special talent.

**416 S**

**417 S**

418 S

419 S

These undoubtedly attractive sketches should not be taken as implying that the aim of all exercises with point and line is to enable one finally to draw like this. They are simply meant as examples of good figurative drawing from observation.

The sense of creative play with pictorial media lies in composition which is free and not tied to the figurative although this by no means excludes figurative drawing as a mode of expression.

**420 S**

**421 S**

**422 S**

Drawings from travel diaries which demon-
strate an eye for the essential and a sure
mastery of line.

**423 S**

**424 S**

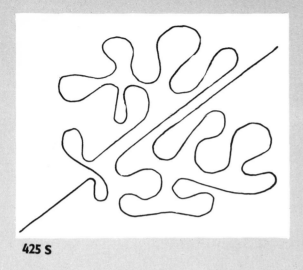

425 S

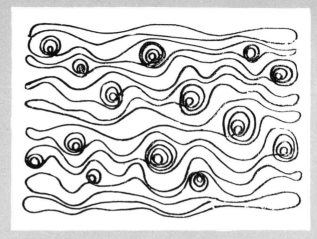

426 S

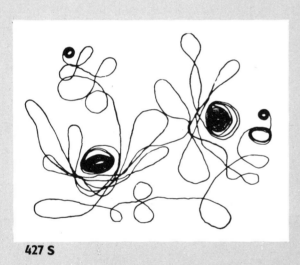

427 S

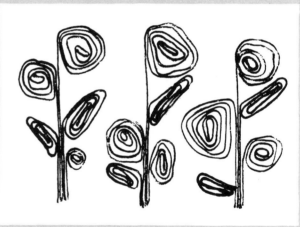

428 G 13

# PLASTIC LINE

A thread glued to board or card creates a plastic line. Soft thread can be stuck on with cellulose glue; tough thread requires a strong all-purpose glue. Work with soft thread, e.g. wool, has the advantage that the thread can be moved about on the glued surface until the desired solution has been reached.

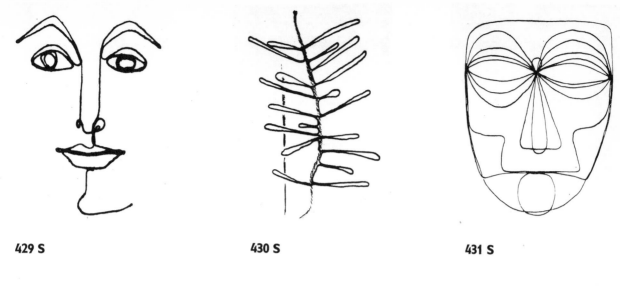

429 S

430 S

431 S

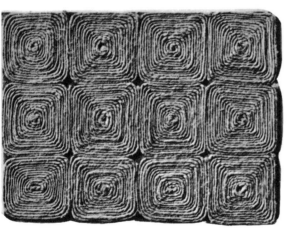

432 G 12

433 B 12

This is not possible when using strong glue.

425-427, 429, 431 show linear patterning with continuous thread. In Figures 427 and 430 two threads have been used. The plant forms in Figure 428 were built up from five threads.

432, 433: Threads laid close together. These create areas of textured surface and plastic line takes on a decorative character.

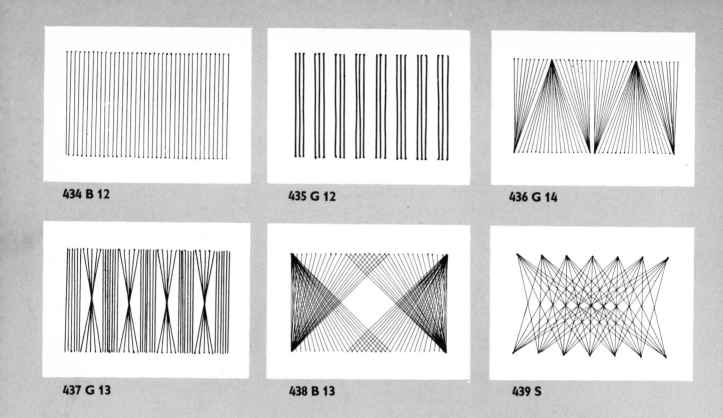

434 B 12     435 G 12     436 G 14

437 G 13     438 B 13     439 S

# STRETCHED THREAD

The requirements for the following exercises are strong cardboard, a sewing needle and some tough yarn. The method is very simple. Holes are bored in the cardboard, through which a thread is drawn and stretched tight. This use of thread produces astonishing results, assuming that it is done to a plan and systematically carried through. A clear demonstration of how this might be done is shown here in the accompanying sequence of illustrations.

434-439: Thread stretched between two parallel lines of holes.

440-459: Exercises in which holes are punched only round the outside of a square or the periphery of a circle. In all exercises it was made a rule that the thread should not be stretched across the rear side of the cardboard but only to the next hole.

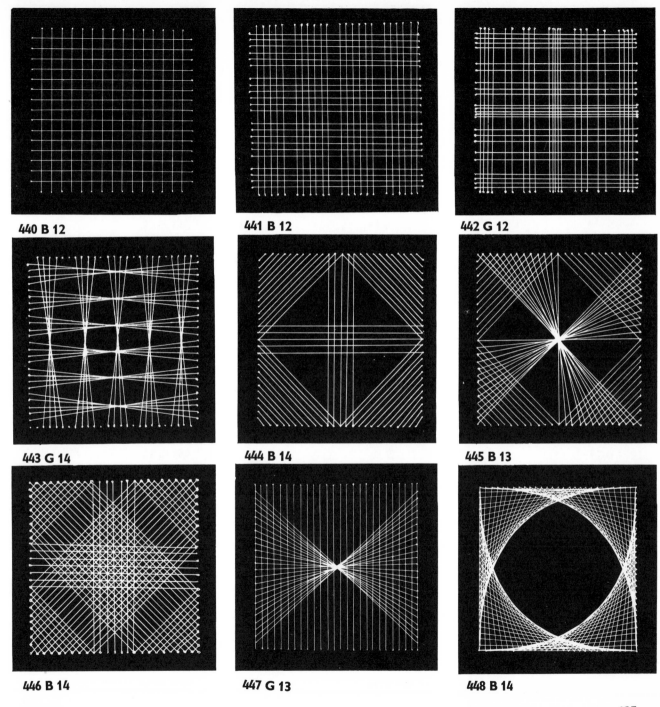

440 B 12

441 B 12

442 G 12

443 G 14

444 B 14

445 B 13

446 B 14

447 G 13

448 B 14

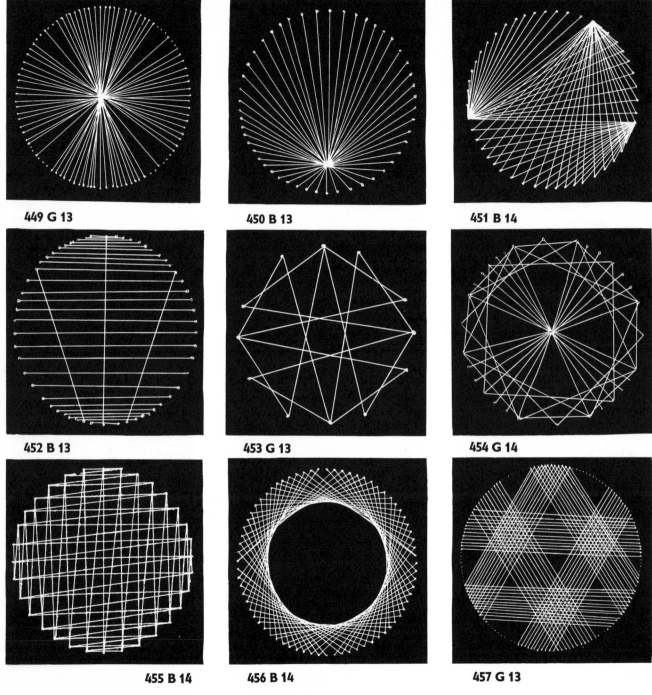

449 G 13

450 B 13

451 B 14

452 B 13

453 G 13

454 G 14

455 B 14

456 B 14

457 G 13

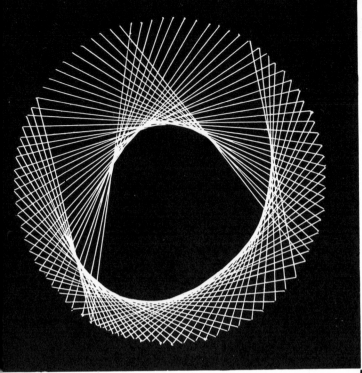

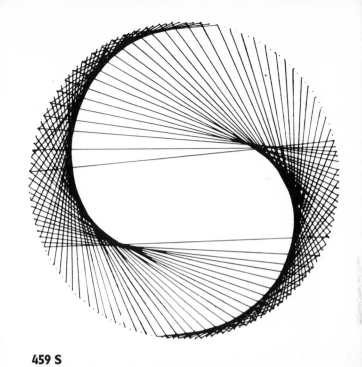

**458 G 15**

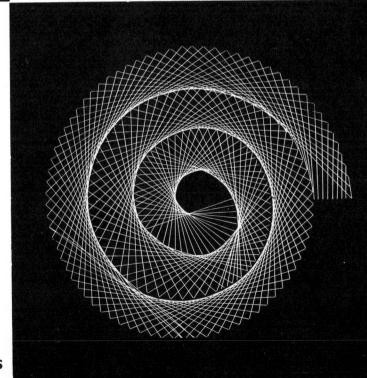

460: Here the basic element is an endless spiral line.

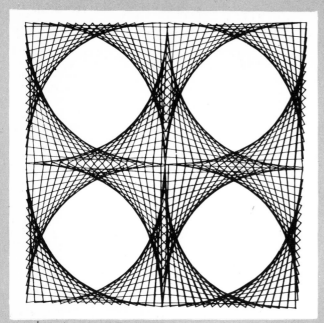

**461 B 14**

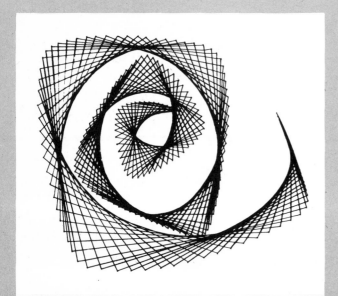

**462 S**

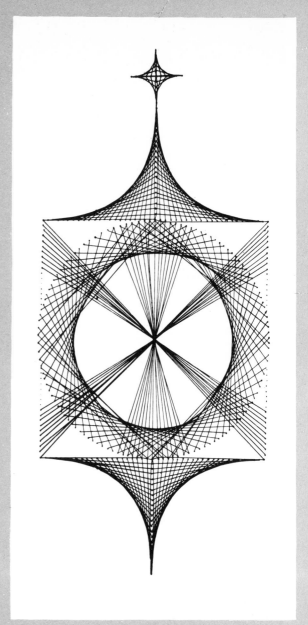

**463 B 14**

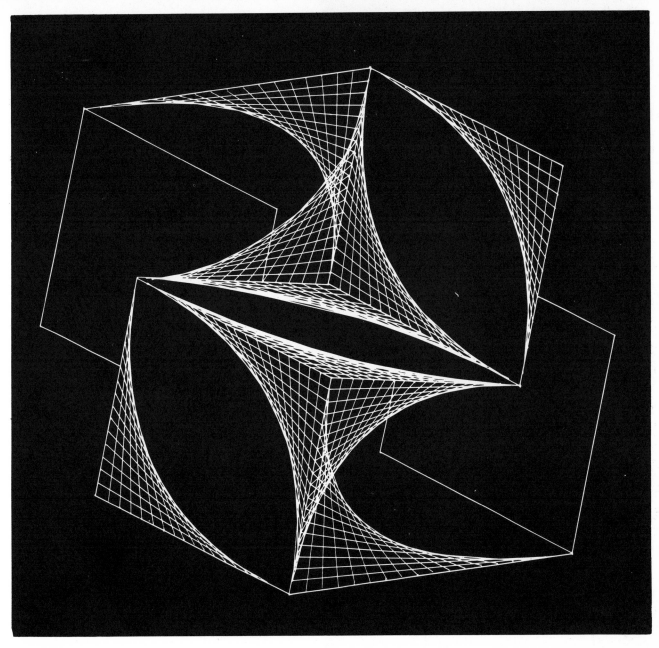

464 S

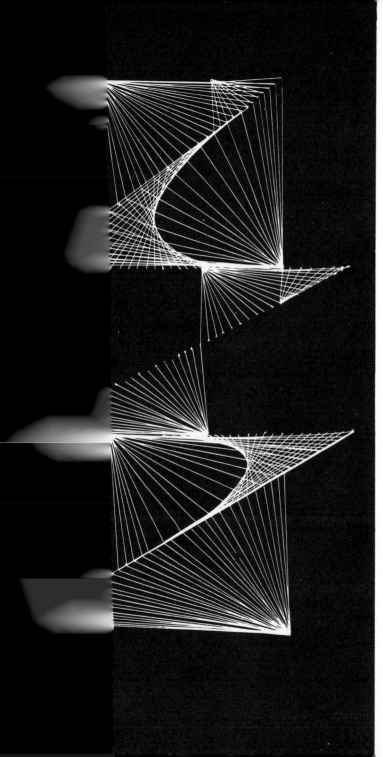

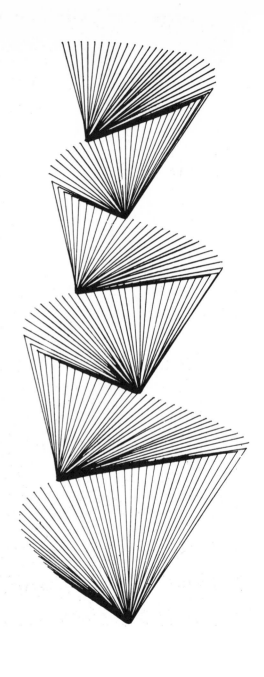

465 S 466 S

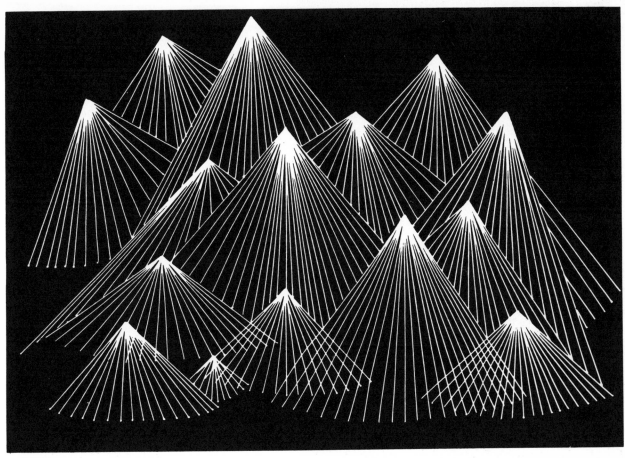

467 S

464-467: In these examples the use of thread is developed to a point where it creates a marked plastic effect. Even these quite complicated linear patterns originate from relatively simple basic forms.

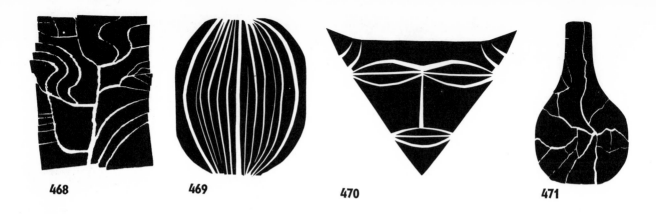

468

469

470

471

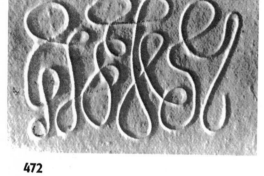

472

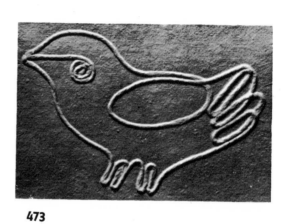

473

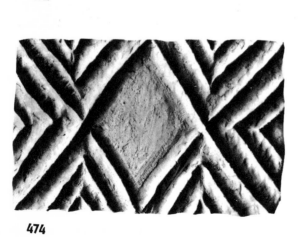

474

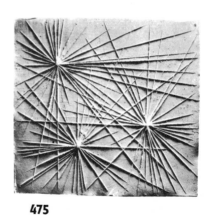

475

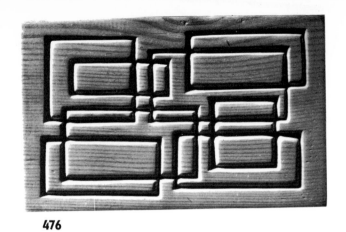

476

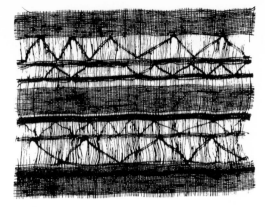

477

# USE OF LINE IN VARIOUS MATERIALS

According to the characteristics of the material used line as a pictorial element may also have different expressive qualities.

**With paper**

468-471: A surface is split or pulled apart (468, 471: torn line. 469, 470: cut line).

472, 473: Linear relief from glued thread.

**With clay**

474: Plastic line formed in clay with the fingers.

475: Clay impression of an intaglio-cut plaster slab.

**With wood**

476: Linear pattern produced with saw cuts; the edges of the cuts are filed.

**With textiles**

477: By modifying the weave (pulling out certain threads) a rhythmic linear design is produced.

These are all the subjects of separate volumes in the Creative Play Series.